EVERYDAY MOBILE PHOTOGRAPHY

*How to take cool photos
using your phone's camera*

Michaela Willlove

EVERYDAY MOBILE PHOTOGRAPHY

Copyright © 2019 by Michaela Willlove.

All rights reserved. Printed in the United States of America. No part of this book may be used or reproduced in any manner whatsoever without written permission except in the case of brief quotations embodied in critical articles or reviews.

This book is a work of fiction. Names, characters, businesses, organizations, places, events and incidents either are the product of the author's imagination or are used fictitiously. Any resemblance to actual persons, living or dead, events, or locales is entirely coincidental.

Komodo Press
Woodside Ave.
London, UK

Book and Cover design by Designer
ISBN: 9781093897395

First Edition: April 2019

10 9 8 7 6 5 4 3 2 1

CONTENTS

EVERYDAY MOBILE PHOTOGRAPHYI

CONTENTS ..1

WHY YOU NEED TO BE SHOOTING WITH YOUR PHONE2

 MY EXPERIENCE WITH SMARTPHONE PHOTOGRAPHY ...5

CHOOSING A PHONE ..9

 READ REVIEWS ...12
 IPHONES VS. ANDROID PHONES ..13
 WHAT WE PRIORITIZE ..15
 ACCESSORIES FOR MOBILE PHOTOGRAPHY ...17

GETTING STARTED ...21

 CHOOSING A CAMERA APP ...21

SMARTPHONE PHOTOGRAPHY TIPS ...23

 KNOW YOUR CAMERA ...24
 NAIL YOUR COMPOSITION ..25
 USE THE LIMITATIONS FOR STYLISTIC EFFECT ...40
 WHAT TO PHOTOGRAPH: A FEW IDEAS ..42

EDITING ON A SMARTPHONE ...62

> Editing on Your Phone ... 63
> Editing on Your Computer .. 68

SHARING YOUR IMAGES .. 71

> #1 Connect to the Web .. 72
> #2 Know Your Phone Plan ... 72
> #3 Places to Share Your Work ... 73
>> *INSTAGRAM* .. 74
>> *FLICKR* ... 79
>> *TUMBLR, TWITTER & FACEBOOK* ... 80
> #4 Read the Fine Print .. 82
> #5 Post ... 83
> #6 Interact ... 86
> #7 The Bigger Picture: Pros & Cons of Sharing Your Work 87

KEEPING YOUR IMAGES SAFE .. 90

PRINTING YOUR IMAGES .. 93

> Ways to Print Your Smartphone Shots .. 93

CONCLUSION .. 97

ABOUT THE AUTHOR ... 98

ACKNOWLEDGMENTS ... 99

Why You Need to Be Shooting with Your Phone

PHOTOGRAPH MORE

UNLESS YOU'RE ONE OF those admirable people who carries their favourite camera with them at all times, at the ready, chances are that you often watch great photographic opportunities pass by you. (Not quite there yet? Start taking photos with your phone regularly, and in no time, the world will be full of photographic potential!)

But nowadays, most of us keep our phones with us all the time, which means most of us have a camera with us all the time too. And because of the advances in smartphone design, that camera does a pretty decent job!

Awesome shots are now within your reach, every where you go. You can easily practice your craft – and add to your visual record – every single day.

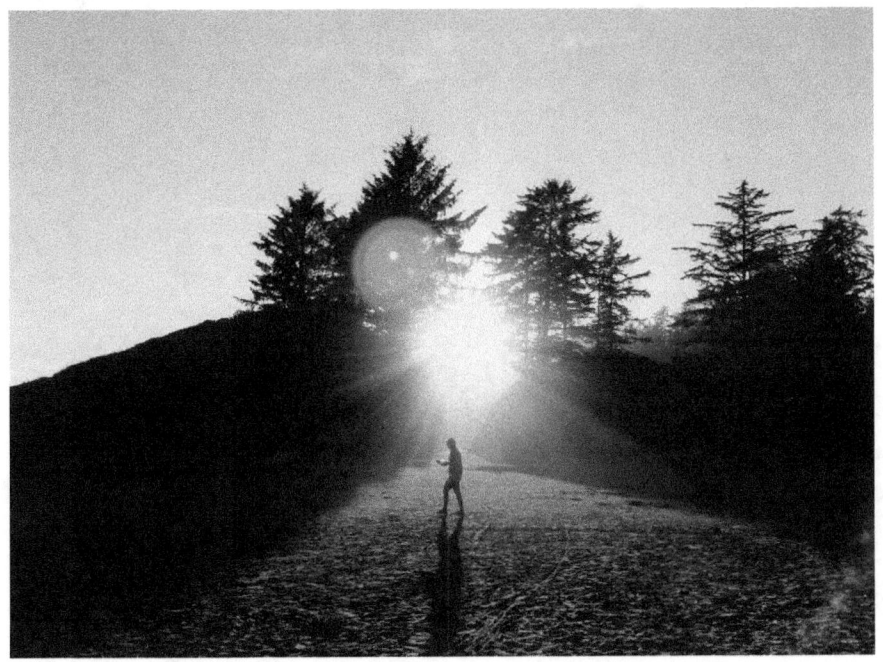

BUILD FUNDAMENTAL SKILLS

Smartphone cameras are nowhere near as powerful as DSLRs, and even some point-and-shoots. The megapixel count is low, and they lack the manual controls that let you achieve shallow depth of field and super-crisp shots of subjects in motion. And the editing apps are nothing compared to programs like Adobe Lightroom and Photoshop.

So, what's the plus?

When you can't rely on your technical or editing powers to create a great shot, you have to go back to the basics: Composition. You need to think more about the light, the colors, the lines, the placement of your

subject. Being forced to focus on those fundamentals will do amazing things for your photography.

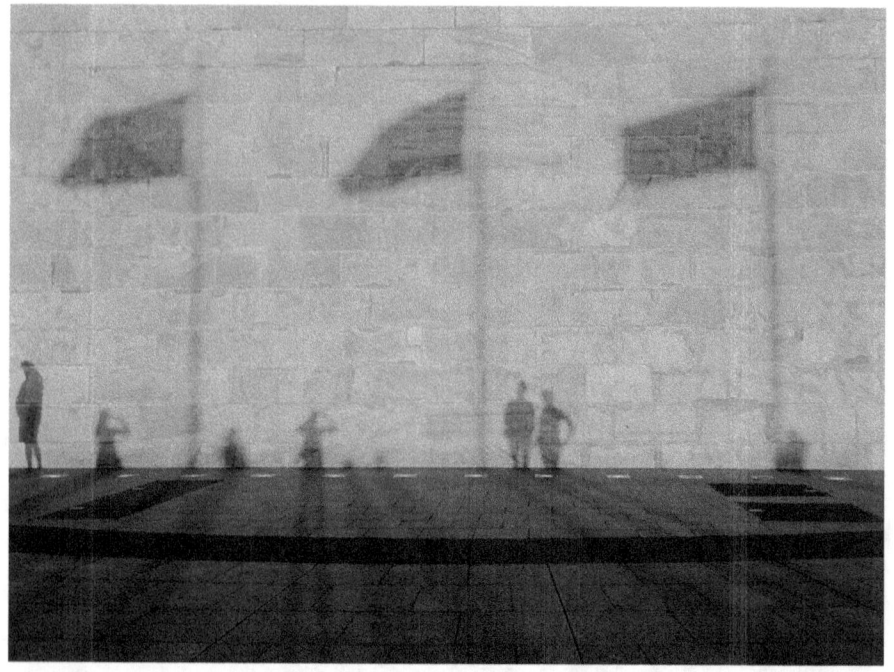

CONNECT

If you're taking photos on a smartphone, chances are you'll want to share them at some point too. Plug into a photo-sharing community like Instagram or Flickr, and get ready to reap the benefits: you'll connect with friends and other photographers, gain valuable feedback, and get inspired. There are even stories of people gaining new clients, lucrative sponsorships and entire careers thanks to their participation in those communities!

MICHAELA WILLLOVE

My Experience with Smartphone Photography

First up, introductions! I'm Michaela. I'm a part-time ninja here at Photography Concentrate. I'll be guiding you through the exciting world of smartphone photography!

Until just two years ago, my cell phone was just that – a *phone*. I took fewer than 20 photos with it over the four years I owned it!

If I wanted to use my camera, which I'd been doing regularly for three years at that point, I used a DSLR. And then it was time to upgrade. I bought a new shiny smartphone.

The day it arrived, Lauren challenged me to share a photo once a day for a year. I accepted and signed up for Instagram that afternoon. And over the past year, things for me have changed.

EVERYDAY MOBILE PHOTOGRAPH

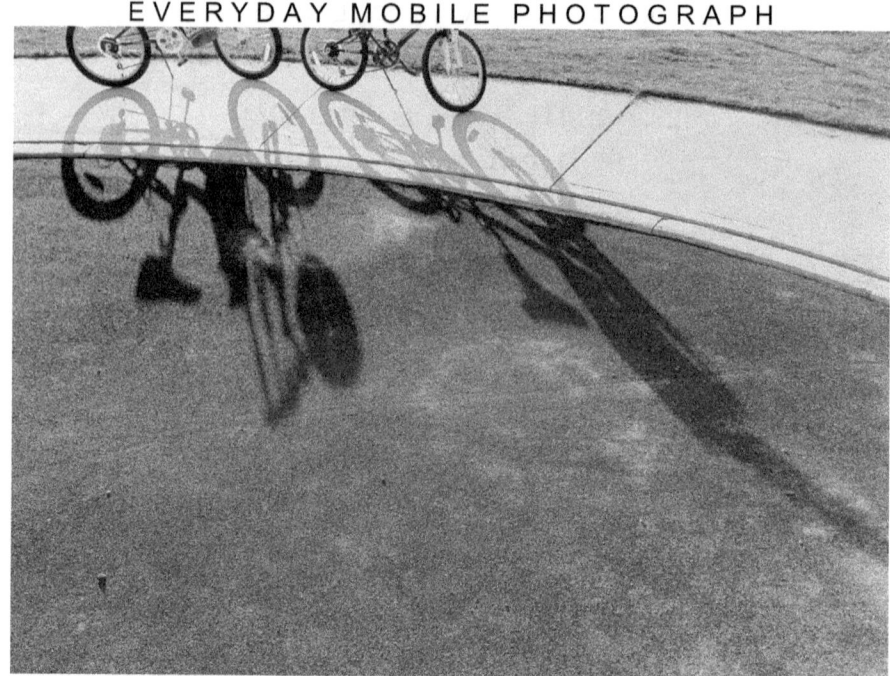

I've taken over 8,000 photos on my phone. I've captured big moments – adventures, birthdays, holidays – moments that, as usual, were also recorded on my DSLR. More importantly, I've captured the small moments that tend to go unrecorded and so are easily forgotten, but that ultimately form the bulk of our lives: bike rides, dinner parties, afternoons at the playground with my nephew.

I've shared over 450 photos on Instagram and looked at thousands of images shared by other people.

I've connected – even if only in a small way – with people I haven't seen in years.

I've made acquaintances with photographers I've never met and been inspired (and intimidated) by their incredible work.

Photography was exciting again. I started running more often, running further, in search of a great shot, getting to know my hometown better in the process. I got up for sunrises, I stayed up for northern lights. I learned more about the technical stuff and experimented with new styles. I *saw* more, I *experienced* more.

There was a cost, too.

I've spent hours editing and captioning (and re-editing and re-captioning) photos. I've battled little insecurities about what I say and share online. But those costs are so small, compared to the record I have: The photos of family, friends and adventures, and the emotions and lessons attached to those images.

Sometimes, I look back on those photos and wish I'd taken them with a better camera, but I know too that if I had only used my DSLR, so many of those photos simply wouldn't exist. So until the day arrives where I bring

myself to tote around multiple devices, always at the ready, it's me and my smartphone. And I'm so excited to see where it takes me.

A NOTE ON THE PHOTOS IN THIS POST

Essentially all of the photos you'll see in this guide were taken with *and* edited on my smartphone, a Nexus 5. Scroll through, and you'll get an idea of what you can (and, in some cases, can't) do with a camera phone.

When I used a different camera or edited a shot on my computer, you'll see a note saying so.

* * *

Choosing a Phone

IF YOU'RE IN THE MARKET for a new smartphone, we unfortunately can't tell you exactly what to buy. For one, we don't know everything there is to know about every smartphone out there! But even if we did, we couldn't say what's right for you, because we don't know you as well as you do! You'll need to think about what's available to you, what you want out of a phone, how much you're willing to pay and so on.

But we won't leave you totally in the dark here. We can, at least, tell you a bit about what to look for in a smartphone from a photographic sense. In the box below, you'll find some of the main points you may want to consider from a photography perspective. Don't think that every phone needs to be a winner on all of these fronts – we simply want to open your eyes to some of the features that are out there and relevant to photographers. Ultimately, it's up to you to decide how to prioritize the things below!

EVERYDAY MOBILE PHOTOGRAPH

A FEW THINGS TO CONSIDER FROM A PHOTOGRAPHY PERSPECTIVE

Image quality
What do the photos coming out of the camera look like? Check for things like sharpness, contrast, saturation and color (white balance and tint). Online reviews with photo examples are a great help here!

Megapixels
If you're looking to share or print your images at larger sizes, as a very general rule more megapixels on a phone is better.

Screen
Consider things like screen size, resolution, and the quality of the contrast. These'll all make a difference in how easy it is to use your camera, especially in tricky lighting conditions, like low light and direct sun. They'll also influence how similar the image on your phone looks to that same image when it's posted online or printed out.

Image stabilization
These days, some smartphone cameras come equipped with image stabilization – a function that reduces blurriness caused by movement of the camera. This can make a big difference in the quality of your photos and videos, especially in low-light conditions!

Video quality

Almost all camera phones can shoot HD video (1080P). But some camera phones support shooting at faster frame rates (for slow motion video). And a few cutting edge smartphone cameras can shoot at an ultra high definition (4K) resolution.

Popularity

As a general rule, if you choose a more popular phone you'll have more options when it comes to apps and accessories, and you'll have an easier time tracking down replacement parts (like USB cables and chargers).

Operating systems & device compatibility

If you're used to working with a particular operating system or want your phone to be compatible with your other devices, you may want to choose a phone from the same brand.

Storage space

If you plan to take a lot of photos (and/or use a lot of apps) you may want to opt for a phone with lots of storage space. Our current phones have 32 GB of space, and we wouldn't want any less.

Battery life

Your battery life will depend on a lot of things (like how much you use your phone and what apps you run in the background), but it's worth getting an idea of what the

maximum battery life is.

Other camera features

Do you care about having burst mode, exposure control, panorama capabilities, etc.? If so, do your research and see whether the phone you're eyeing comes with those features (or a relevant app).

Price

As a general rule, the better the camera features, the more expensive the phone will be. If you're serious about smartphone photography, it may be worth it to pay the premium. But don't lose sight of the fact that smartphones still don't match the quality of DSLRs or even advanced point-and-shoots (the photos from which you can share on platforms like Instagram and Flickr).

Read Reviews

If you're not camera savvy (or phone savvy), check in with someone who is! Don't know anyone? No worries. The internet is full of reviews by people who know their microchips from their megabites. Here are a couple of review sites we recommend checking out before you buy.

TOM'S GUIDE

Here you'll find a ranking for the best smartphone cameras of 2015, as chosen by the tech website, Tom's Guide. Each pick comes with a full review, so you can get a good sense of what makes each camera stand out.

(CONT')QUICK TIPS FOR BETTER SMARTPHONE

or a line)? If so, consider recomposing to eliminate distractions.colorbefore you snap your shot, do a quick check of all four corners of your frame. Is there anything there that'll distract from your subject (like a pop of **Check your corners:** When your subject is pressed up right against the edge of your frame, it can be a little

iPhones vs. Android Phones

A virtual ton has been written on the merits of iPhones and Android phones (as a quick internet search will attest!), so we're going to keep this

brief.

There are two main types of smartphones that dominate the market: iPhones and Android phones. iPhones are made exclusively by Apple, and run the iOS operating system. In contrast, Android phones can be made by a bunch of different companies (Samsung, LG, etc.). The name instead comes from the operating system those phones run – the Android system developed by Google.

If you're not sure whether to get an iPhone or an Android phone, here are a few things to consider:

ACCESSORIES, APPS & COMPATIBILITY

Historically, iPhones have been the popular choice among smartphone users (or at least users who are willing to invest in expensive gear) and so companies have been eager to develop apps and accessories that are iPhone-compatible. On the accessories front, this is helped by the fact that there are relatively few models of iPhone being used at any given time. Manufacturers can know that if they make an iPhone accessory, it will be compatible with a huge number of phones.

Now contrast that to Android phones. Though they occupy a larger share of the market than they once did, there are considerably more types of models out there – and so less incentive to make accessories. On the apps front, things are levelling out a bit, though iPhone users still seem to have a bit of an edge (iPhone users enjoy higher quality uploads to Instagram, for example).

Finally, some tech gear is compatible only with certain phones. Anyone who wants an Apple watch, for example, will need an iPhone 5 (or a newer model).

MICHAELA WILLLOVE
CAMERA QUALITY

iPhones are generally considered to have the best cameras, and Apple is always pushing to improve the camera between models. Android phones tend to lag behind a bit, though the latest round of Android phones – especially phones developed by Google – are edging in.

PRICE

If you want a new, unlocked iPhone 6 with a decent amount of storage space, it will cost you over US$700. Equivalent Android phones are considerably less expensive.

What We Prioritize

We personally look for a smartphone that has a great camera and suits our other phone needs, prioritizing an easy-to-use operating system, great aesthetics, a good price and a fair warranty.

A photo straight out of my smartphone's camera, taken in low light.

On the camera front specifically, we want a camera app that's easy to use (or to know that we can download a better alternative) and great image quality. We recommend looking at reviews that show how image quality changes under different conditions, paying attention to things like contrast, color quality, saturation and sharpness.

A photo straight out of my smartphone's camera, taken in direct sunlight.

All that being said, your priorities may be different from ours – it's your call! But if we can recommend one thing above all else: try the phone before you buy. See if you can play with a friend's phone, or head to a store to try out a test model. Is it intuitive to use? Do you like the look of the photos? Does it seem like the right fit for the price?

Accessories for Mobile Photography

When it comes to accessories, all you really need to get started with smartphone photography is a smartphone with a camera app and a charger.

But a case and screen protector should be bought ideally *the same day you get your phone.*

EVERYDAY MOBILE PHOTOGRAPH
THE ESSENTIALS - CASE AND SCREEN PROTECTOR

Make sure you set yourself up with a good phone case and screen protector.

You'll kick yourself if you scratch your pricey phone because you were unwilling to shell out a few extra bucks for the protective gear!

A quick Google search of your model plus the terms 'case' or 'screen protector' will help you track down good options. We bought ours at Best Buy.

As mobile phone photography becomes more popular, all kinds of new accessories and gadgets pop up.

Here are a few (usually) non-essentials that you might want to consider, beyond the run-of-the-mill case and screen protector.

TELEPHOTO LENS ATTACHMENT

This lens magnifies x18 so distant objects appear extremely close. It attaches to the phone's lens by using a clamp.

It also comes with a tripod that helps steady the phone to avoid blur caused by camera shake.

I took this lens for a spin in the zoo, and you can see the results below. You can get this lens from Amazon.

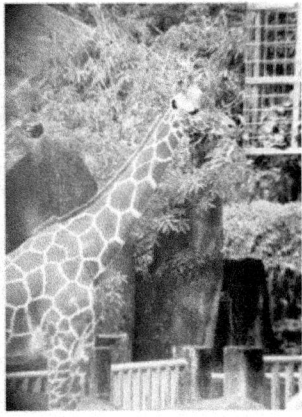

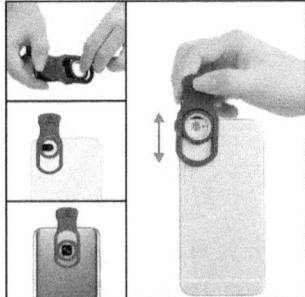
Step 1: Adjust the clip slowly, the metal ring can move along the groove, make sure the lens is centered over your phone's camera.

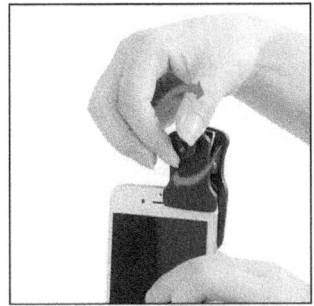
Step 2: Tighten the clip screws to stabilize the clip.

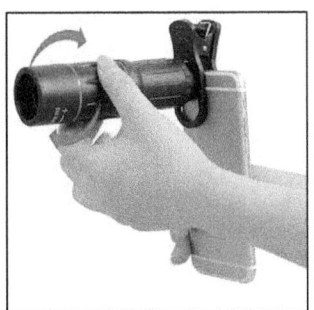
Step 3: Attach the lens onto your mobile phone with the lens over your phone's camera.

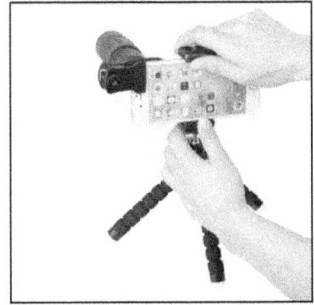
Step 4: Now you are ready to take pictures.

Above: Zoo photo result using Telephoto and steps for attaching the Telephoto lens

EVERYDAY MOBILE PHOTOGRAPH
PORTABLE BATTERY PACK

A portable battery pack allows you to recharge your phone from a battery. It's a great extra for campers, hikers, travellers and anyone whose phone runs out before their desire to take photos does!

WATERPROOF CASE

A fully waterproof case will allow you to submerge your phone in water for a period of time – you'll be able to snap shots without a problem in rain, snow or even in a pool or the ocean! Some of these heavy-duty cases are so thick that they may reduce the responsiveness of your touch screen, so read reviews before you buy.

LENSES

These days, you can find a whole suite of lenses specifically designed for smartphone photography, including wide-angle and macro lenses. We haven't tried them ourselves, but reviews abound!

Getting Started

ALRIGHT, SO YOU'VE GOT YOURSELF a fancy smartphone – congrats! You're probably itching to start taking awesome photos, but first things first: Let's make sure you've got the best camera app for the job.

Choosing a Camera App

When you purchase a smartphone, it will most likely come pre-programmed with a default camera app. In some cases, this app will be exactly what you need! And in some cases...well, let's just say you can do better.

To evaluate the quality of your camera app, first make sure it has all its features enabled (in some cases the default setting may be for the extra features to be turned off). Once your camera app is fully enabled, test it out to see what it lets you do. If you like the functionality, awesome! If not,

you might want to try an alternative from your app store.

Not sure what you should be looking for? Here are a few things we think a camera app should allow you to do:

There are some camera apps out there now that allow you to gain even more control over the look of your images. For example, some let you adjust your settings manually, shoot in High Dynamic Range, and even shoot in .tiff or .dng formats to minimize image compression. You can definitely get by just fine without this level of control, but feel free to experiment with these more advanced camera apps if that sounds like your kind of thing!

And note too that some editing and sharing apps (like Instagram) include a camera function as well. There's a lot of choice out there!

CAMERA APPS - BASIC FEATURES TO LOOK FOR

- **Add gridlines to your frame:** This makes it easier to get your subjects centred, your horizons level, etc.
- **Enable or disable flash**
- **Set a timer**
- **Adjust your exposure level easily**
- **Lock your focal point and exposure level:** Once you've locked focus or exposure, you should be able to recompose your shot without the focal point or exposure level changing
- **Shoot video**

MICHAELA WILLLOVE

Smartphone Photography Tips

WHEN IT COMES TO OUR SMARTPHONE photography, our general philosophy is to see the camera's limitations as its advantages.

Here's what I mean.

Camera phones are not nearly as powerful DSLRs. They're not even as powerful as some point-and-shoots out there. For the most part, they lack the manual controls or the hardware you need to say, create a dreamily shallow depth of field, get a crisp shot of someone in motion, or produce a shot in low light that's not peppered with noise.

Here's the good news: When you're limited technically, you have to push yourself in other ways to make a shot work. And, as you'll soon see, in pushing yourself to get great shots from your camera phone, you'll be developing fundamental skills – some of the nuts and bolts of great

photography!

So let's dive into it, and learn how to take compelling shots with your smartphone camera. Once we've got the basics down, we'll hook you up with some ideas of what to photograph, to help you dive right into smartphone photography.

Know Your Camera

First things first: Get to know your camera. Test out its various modes (panorama, video, etc) in different conditions – like low light, direct sun, and when your subject is moving – to see what the different modes excel at and where they fall a little short.

For example, my phone has both a standard mode, where I can manually adjust my exposure, and an high dynamic range (HDR) mode, that produces a single shot from several images taken at different exposures.

My default is to shoot on HDR, as the resulting shot looks more true to life in its gradation of light to dark tones and its color (counterintuitive, but there we are!). I switch over to the standard mode whenever I need to seriously increase or decrease the exposure, or in low light conditions (where the HDR mode struggles to focus). My camera also has a lens blur function that allows me to mimic a shallow depth of field, but it's a bit clunky so I don't use it much.

Knowing how your camera's different modes work will help you have more control over the final look of your shots. All it takes is a little bit of practice!

And don't forget that you can download 3rd party camera apps that can give you additional functionality.

MICHAELA WILLLOVE

Nail Your Composition

Spend a bit of time on Instagram, and you'll discover that photographers with big followings have something in common, whether they photograph fashion, families, wildlife or waterfalls . That common feature: A great compositional style.

What is composition, you ask? In essence, when you *compose* a shot, you're choosing how to arrange the visual elements in your frame – elements like lines, shapes, colors and light. The resulting arrangement is your *composition.*

> "Composition is the placement or arrangement of visual elements or ingredients in a work of art, as distinct from the subject of a work." – Wikipedia.

Your composition impacts not only the look of your image – like whether it feels static or dynamic – but also how your viewer *thinks* and *feels* about it. A shot of a several pedestrians crossing a street may not catch your eye, but a shot of a single pedestrian could convey a range of feelings or ideas, from loneliness to adventure.

With smartphone photography, composition is key because, for the

most part, everything in your frame will be in focus. You can't adjust your aperture to blur out all the background details, so you have to work a bit harder to make sure the elements in your frame make for a great shot that communicates your message.

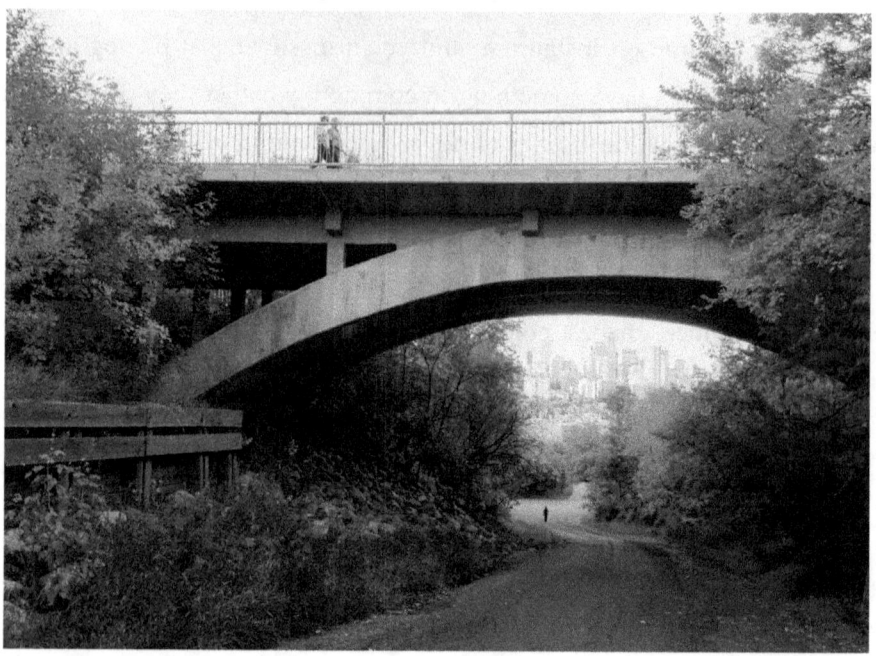

Plus, chances are that if you're posting to Instagram, you're going to be doing the bulk of your editing with a not-so-powerful editing app, rather than Lightroom or Photoshop. You have to get it right in-camera – your app's not going to save you from bigger mistakes!

Here are a few things we look for when we compose photos with our smartphones:

LIGHT

Light can have a big impact on the look and feel of your images. Imagine the same scene lit by the soft golden light of sunrise versus the harsh, shadow-creating light of midday.

Light can also help direct attention. We tend to look first at things that are brightly lit, or lit in way that differs dramatically from the rest of the scene.

Light can change the color of your shot, too! For example, daylight tends to be neutral or slightly blue, sunrise and sunset light tends to be warm, and the light before sunrise and after sunset is much more blue. Because cameras don't adjust for changes in the color of light as well as our eyes do, these colors can show up quite strongly in your photos.

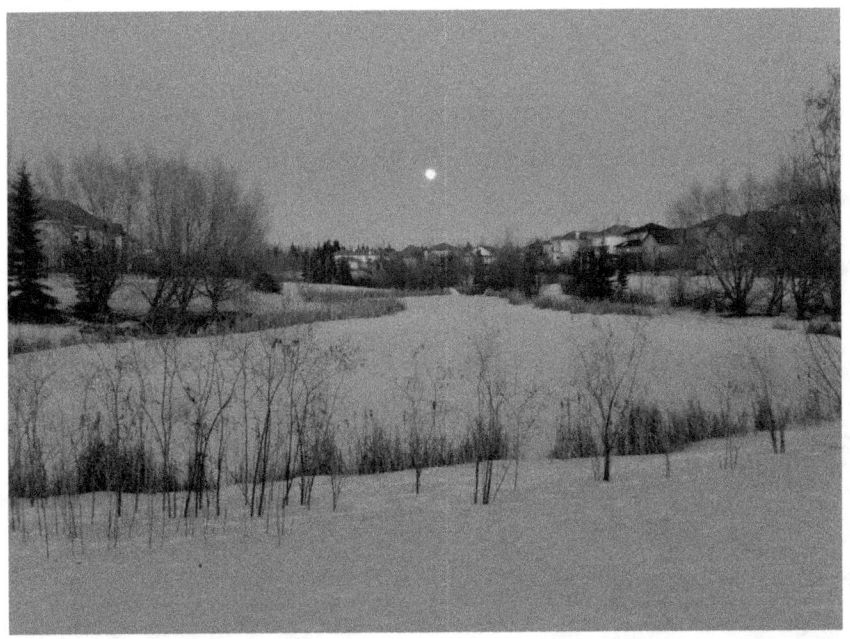

Above: After sunset, natural light tends to have a blue cast. My eyes knew that the snow was white, but my smartphone camera registered it as super-blue – no editing applied!

Keep the different effects of light in mind as you shoot, and look for light that enhances your message. If you don't like the effect a light source is having on your image, change it up – turn off an overhead light and shoot only with window light, come back to your shot at sunset instead of

midday, or reposition yourself (or your subject) until the light falls where you want it to.

LINES

Lines are hugely powerful elements! See, our eyes love a good line. Whether it's wavy, straight or curved or implied (like a line created by loosely spaced people), our eyes will latch onto the line and follow it to the end.

Here's what that means for your photos: If you want your viewer to look at your subject, place them at the end of a line (or a series of lines, for even more attention-directing power!).

Above: The diagonal lines of the staircase are a magnet for your eye! Place your subject at the end of those lines, and your viewer is sure to see them!

MICHAELA WILLLOVE

There are all kinds of lines out there, and they do different things for our photos. Horizontal and vertical lines tend to feel static, diagonal lines tend to feel dynamic, and wavy or curved lines are both dynamic and a little gentler. If you want to create a particular feeling in a shot, incorporate the types of lines that enhance that feeling!

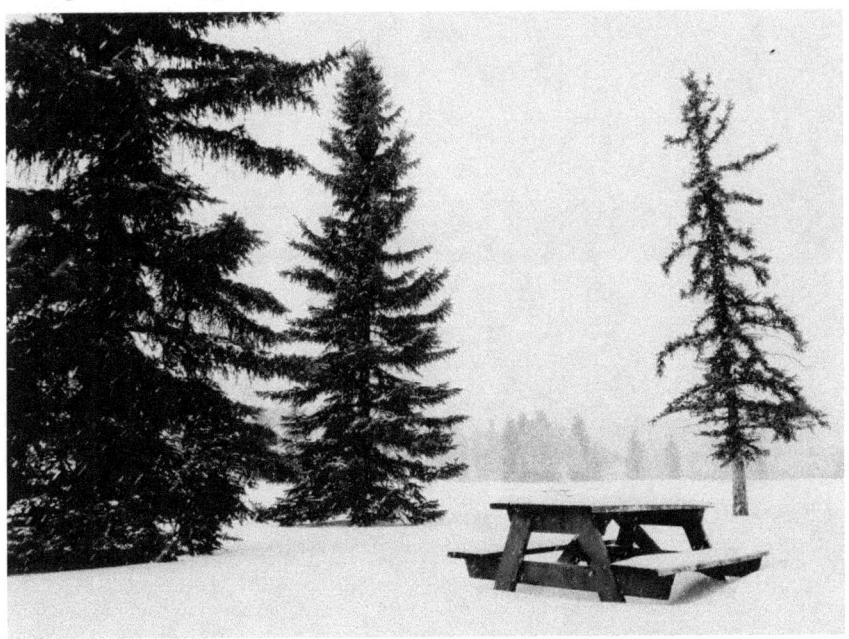

EVERYDAY MOBILE PHOTOGRAPH

Above: In the first image, the diagonal lines of the trees and picnic table give the shot a more dynamic feel. In the second image, when those lines are straight, the shot feels much more static.

SPACE

Look at the two photos below. Which photo makes the subject stand out more? It's the one with all the empty space!

MICHAELA WILLLOVE

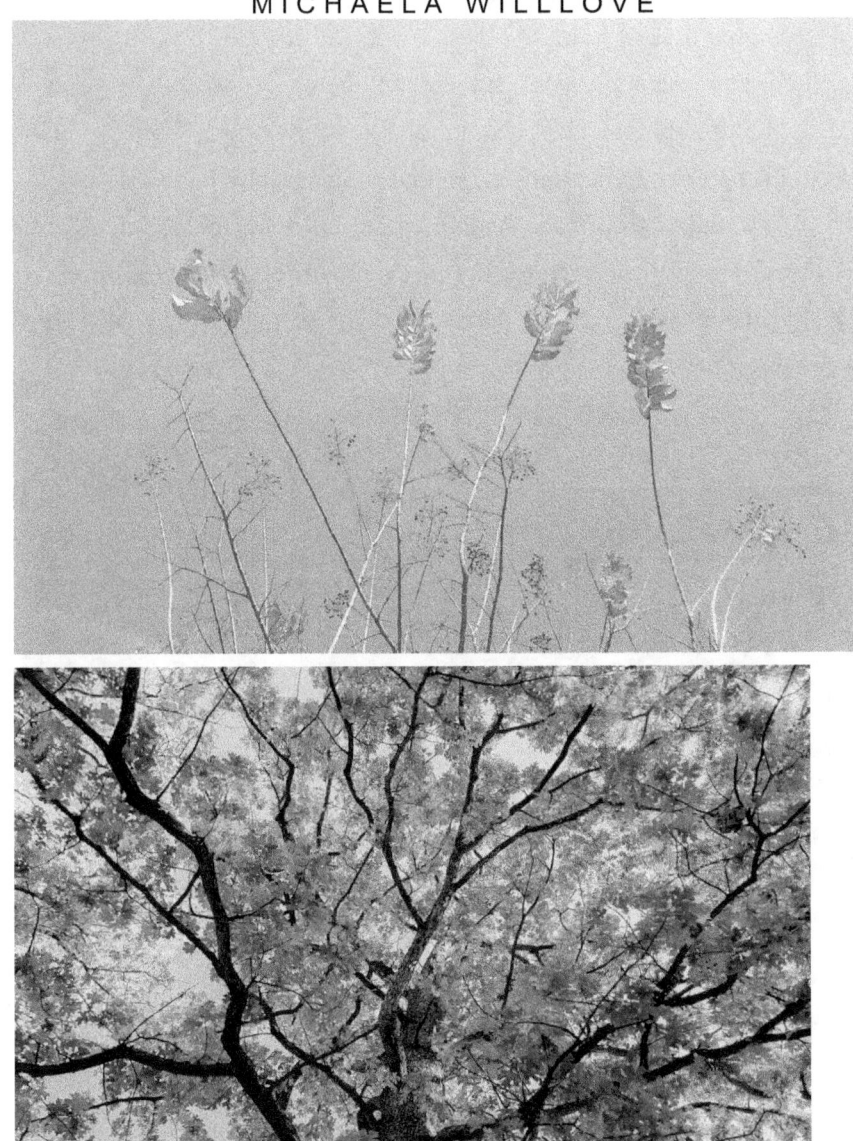

Above: Against a stark blue background, the branches and leaves of the tree really grab your attention. In the second shot, it's not as clear where

EVERYDAY MOBILE PHOTOGRAPH

you're supposed to look first.

When you surround your subject with empty space – or *negative space*, as photographers call it – it simplifies your frame. There are fewer things to distract from your subject, so that subject really pops.

The sky makes for great negative space, but look for non-distracting space elsewhere too – in architecture or even nature! Just make sure there aren't any major elements (like bursts of color or major lines) that draw your eye away.

Above: There are tons of elements at play in the shot above, and no real negative space. If we dropped a subject in there – like a person – all of those elements would likely distract. But, on its own, it's an interesting shot full of details!

And sometimes, you may want no negative space at all! An image that's purposefully brimming with elements can be interesting too!

MICHAELA WILLLOVE
FRAMES

Like empty space, frames can help put the focus on your subject. They seem to shout out: *Hey look! This thing here is so important that it gets its own frame!*

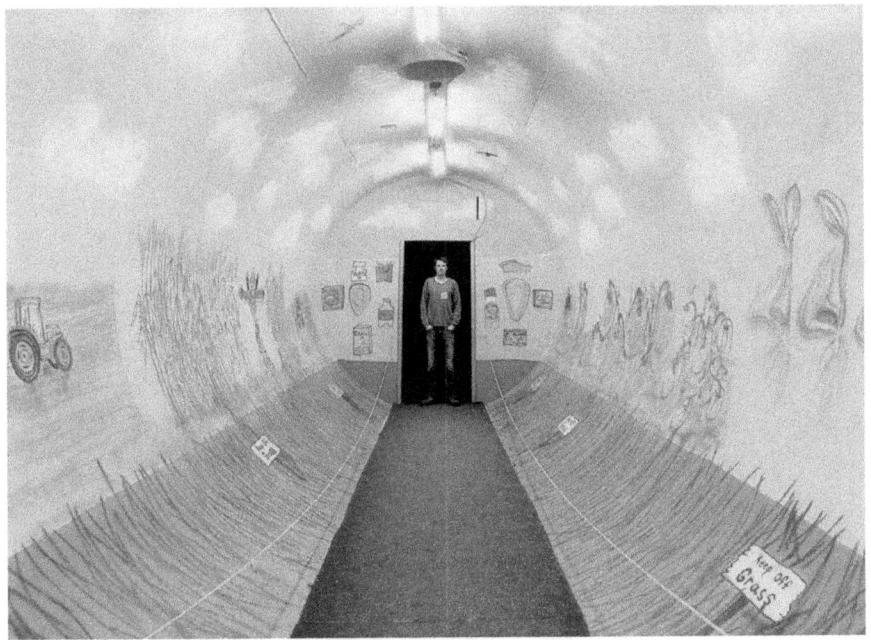

Above: Placing your subject in a frame – in this case a literal one (the doorframe) – is a great way to draw attention to them!

Frames have the bonus feature of adding cool visual interest to your shot. Get creative with your frames, finding them in trees, architectural features – you can even make frames with your hands!

COLOR

Color can play a huge role in your images!

Just think about it! Color can change the mood of your scene: an

EVERYDAY MOBILE PHOTOGRAPH

image filled with rainbow shades will feel a lot different than one with muted tones, and an image in color will feel different than that same image converted to black and white.

Color can also direct your viewers attention: a pop of color that differs from the rest of the tones in your scene is going to *stand out*.

Above: Even though the texture is pretty similar across the frame, your eyes can't help but jump to the bright pop of red.

So pay close attention to the colors in your scene. Do they enhance your message, or conflict with it? Do they direct attention to your subject, or distract from it? If the colors aren't working, and you don't intend to convert to black and white, consider recomposing!

INSTAGRAM TIP: COLOR

MICHAELA WILLLOVE

Some Instagrammers take their consideration of color a step further by paying attention to how the colors mesh *across different photos* in their gallery. You'll find people who chase particular shades, and some whose galleries seem to change color over time. It takes work and restraint to post only photos that fit within a color scheme, but it's a great way to push yourself to get out and look for a shot!

REFLECTIONS & SHADOWS

Reflections and shadows are great elements to play with in your photos!

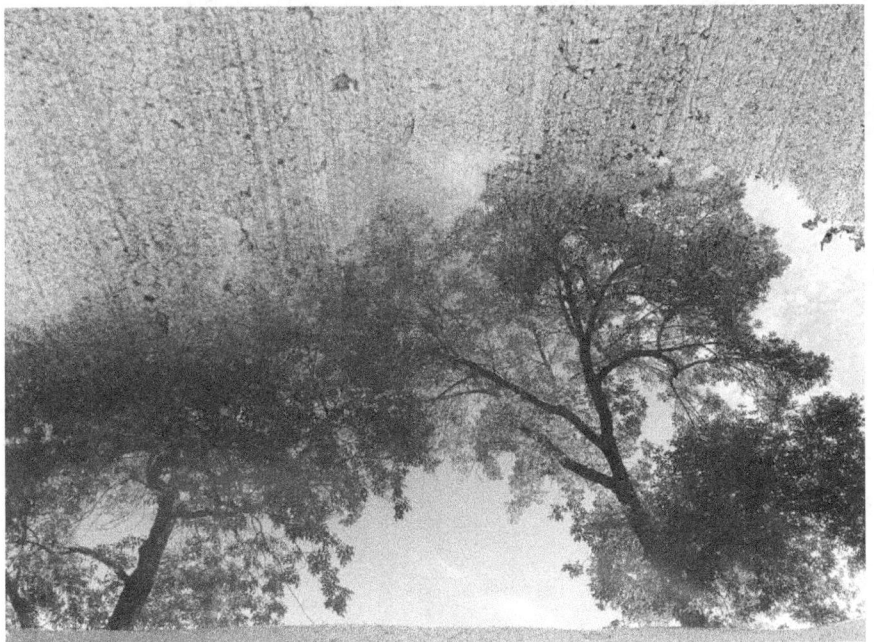

Above: In this photograph of a puddle (flipped upside down), the reflection of the trees serves as the subject and allows the viewer to imagine the scene that exists outside of the frame.

An interesting reflection or shadow can be a subject in its own

EVERYDAY MOBILE PHOTOGRAPH

right. It can also be used to suggest that space exists beyond the frame, adding intrigue to your image.

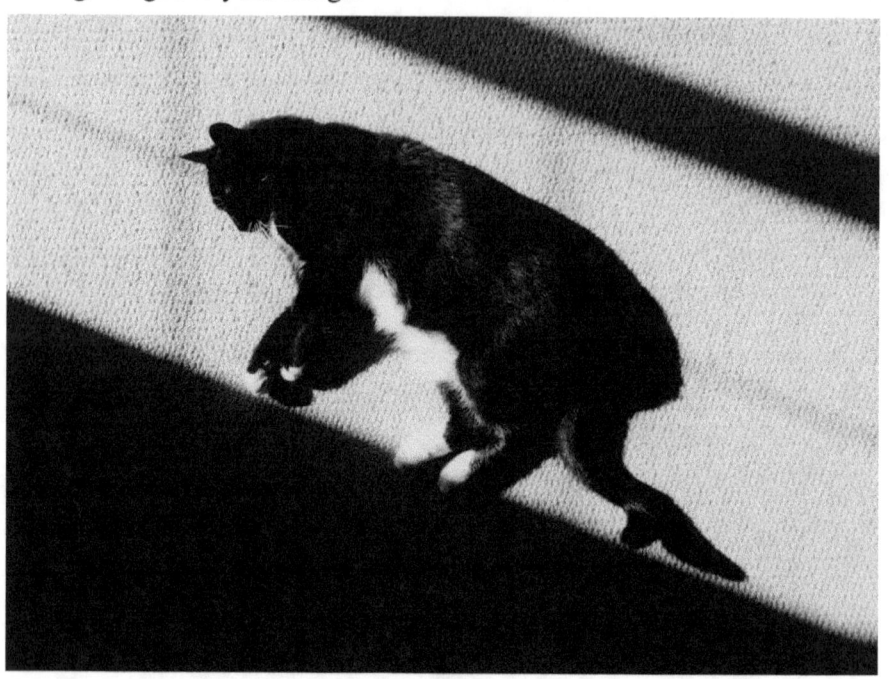

MICHAELA WILLLOVE

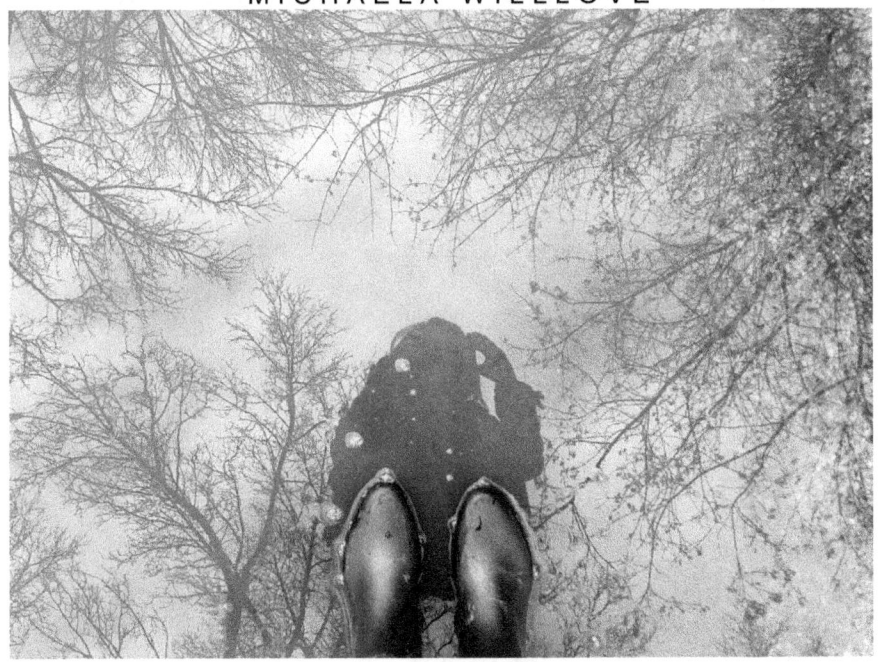

Above: In the first photo, strong shadows create lines that frame the napping cat. In the second, my reflection forms part of the subject (along with my rubber boots), while the reflection of the trees serves as a frame.

Plus, reflections and shadows can *create other elements* like lines or frames – elements that can be used to direct your viewers' attention to a particular part of your scene. Give it a try!

QUICK TIPS FOR BETTER SMARTPHONE COMPOSITIONS

- Straighten up: when a line that should be straight – like the horizon – looks askew in a photo, it can be distracting. So unless you purposefully want a line to be askew, take extra care to get your lines straight. Enabling the gridlines on your camera makes this a lot easier!
- Get your subject out of the center: placing your subject in the center of your frame can get a little boring after a while. Give the *rule of thirds* a try: imagine your frame is divided into a 3x3 grid, and place your subject along one of the resulting gridlines or where two gridlines intersect.

COMPOSITIONS DXOMARK

uncomfortable to look at. Give it some breathing room by leaving some space between it and the edge of the frame. (And of course, break with this idea entirely if it doesn't suit your intended effect!) **Leave a little room at the edges:** This site will give you an in-depth review of the camera on almost every major smartphone out there. We particularly like the intuitive design of the reviews, which awards a score out of 100 for things like exposure and contrast, color, autofocus, noise, stabilization, noise and more – for both photos and videos!

EVERYDAY MOBILE PHOTOGRAPH
Use the Limitations for Stylistic Effect

SHUTTER SPEED

Sometimes, your phone is going to reduce your shutter speed to let more light in. And that means, anything that's moving may end up being blurry.

So take advantage of it! Purposefully create images that capture with blurry elements – they can lend your photos a more dynamic feeling. In some cases, they can even result in some pretty cool, abstract-looking shots.

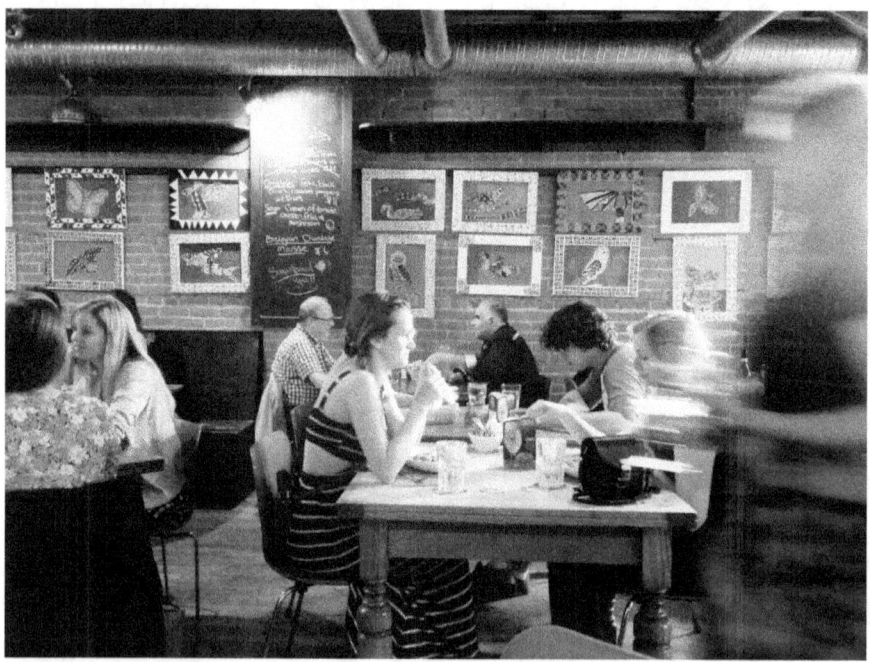

Above: To combat the low light conditions of the restaurant, my phone automatically selected a low shutter speed. As a result, the waitress walking through the shot ended up blurry. And that was great – it better conveyed the bustling nature of the place!

MICHAELA WILLLOVE
AUTOFOCUS

While we've found the autofocus on our phones to be pretty good, it's not perfect – sometimes, it misses the focus altogether. Use that! The resulting blurry shots may look a bit like impressionist paintings. Kinda cool!

Above: To be fair to my phone, I was taking this shot while I was on a moving bicycle, and my subject was moving too. The camera struggled to find focus, but the blurry result is kind of cool!

DYNAMIC RANGE

If you're used to shooting with a DSLR or other advanced camera, you'll quickly learn that your phone can't capture the same dynamic range – the range of tones between the lightest and darkest point in your scene. But that's ok! Darker darks can add more mystery to your photo, and blown highlights can look ethereal.

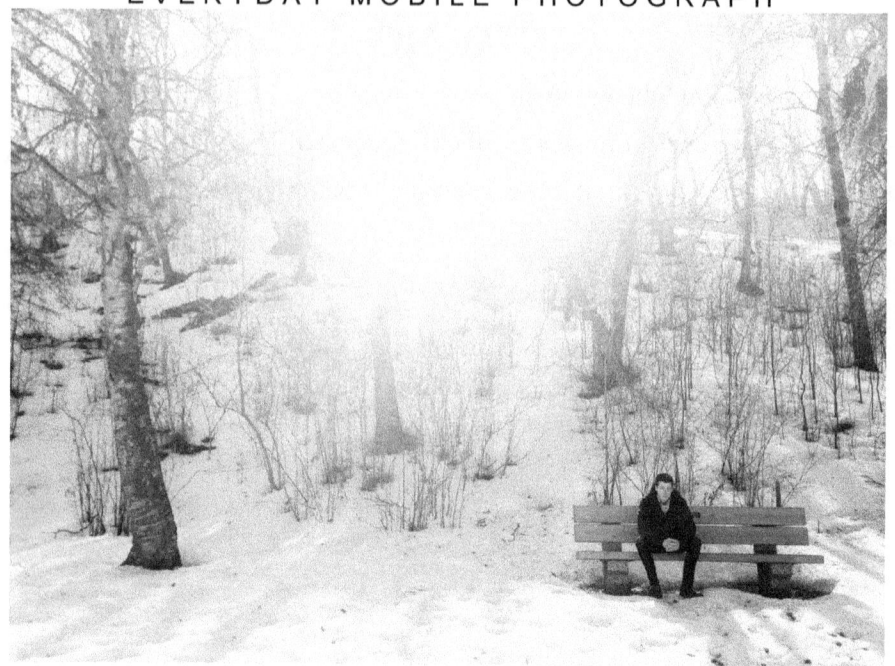

And if you absolutely need to capture more dynamic range, try shooting on your phone's HDR mode (if it has one), or leave your phone in your pocket and switch back to your more advanced camera.

What to Photograph: A Few Ideas

Even with the technical limitations of a smartphone camera, there's still a huge amount of choice when it comes to deciding what to photograph. If you're not sure where to start, here are a few basic ideas to help get you in the smartphone photography mindset. Don't feel like you have to do all (or any!) of these. Use them as a starting point to get your own ideas flowing. Pretty soon, you'll find your (smartphone photo) voice!

MICHAELA WILLLOVE
DAILY LIFE

One of the big trends with photo-sharing services – especially Instagram – is to use the service as a visual diary or journal. That means that instead of just sharing your commercial work or your holiday snaps, you use photography to give people a look into your everyday life – what you're eating, where you're going, who you're hanging out with, little details in your everyday environment that catch your eye.

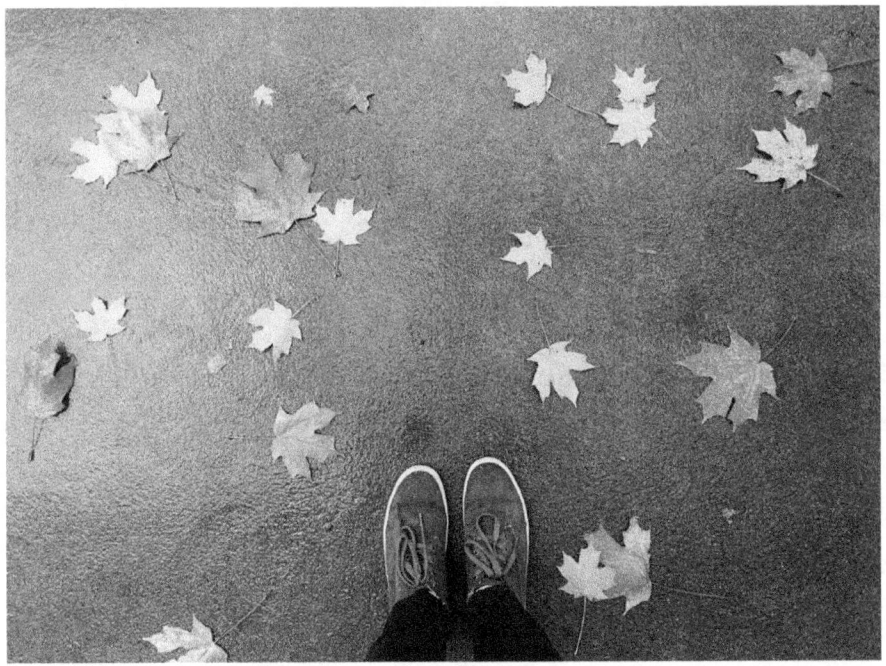

There's even a dedicated hashtag – #widn or "What I'm Doing Now" – that some Instagrammers use to show their followers what they're up to at that very moment (typically at the request of another user who's asked them to share!).

EVERYDAY MOBILE PHOTOGRAPH

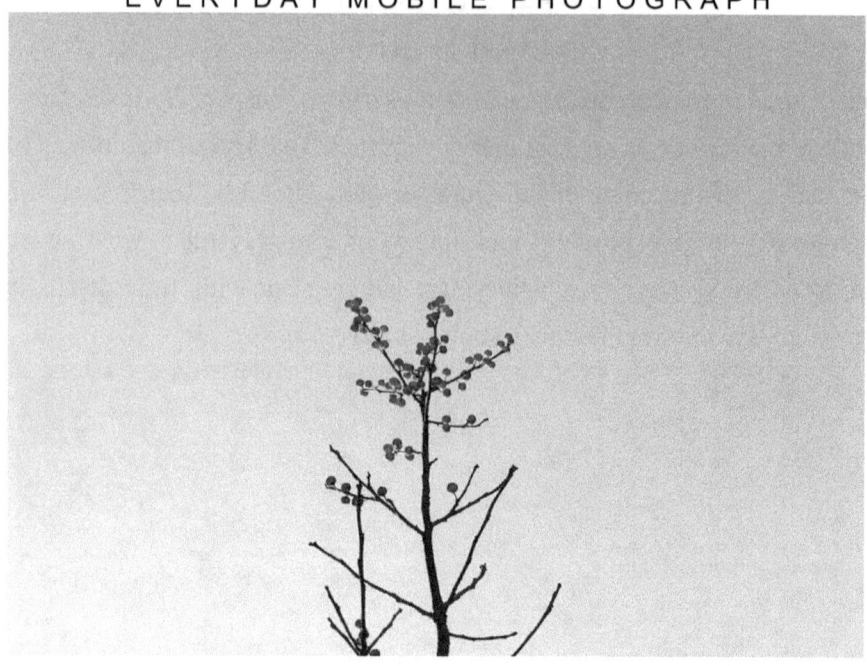

It may seem a little silly at first, to photograph such small things. But in our experience, looking for photo-worthy moments in everyday life makes us better photographers in the long run because <u>it forces us to practice *seeing*</u>. Plus, we have to admit, it's awfully nice to be able to scroll through our shots and have a visual record of moments we might otherwise forget!

VACATIONS & ADVENTURES

There are plenty of reasons to take photos on your next vacation or adventure: You'll be doing cool things that you'll want to remember, you'll be visually inspired by a change of scenery, you'll have more time for it.

But chances are, if you're like us, you'll want to capture most of those things on one of the best cameras you have – the memories you create when you're travelling are special ones and you want to do them justice!

So, when we travel, do we let our smartphone camera take a break? Nope, no sir, no ma'am! Let me tell you why.

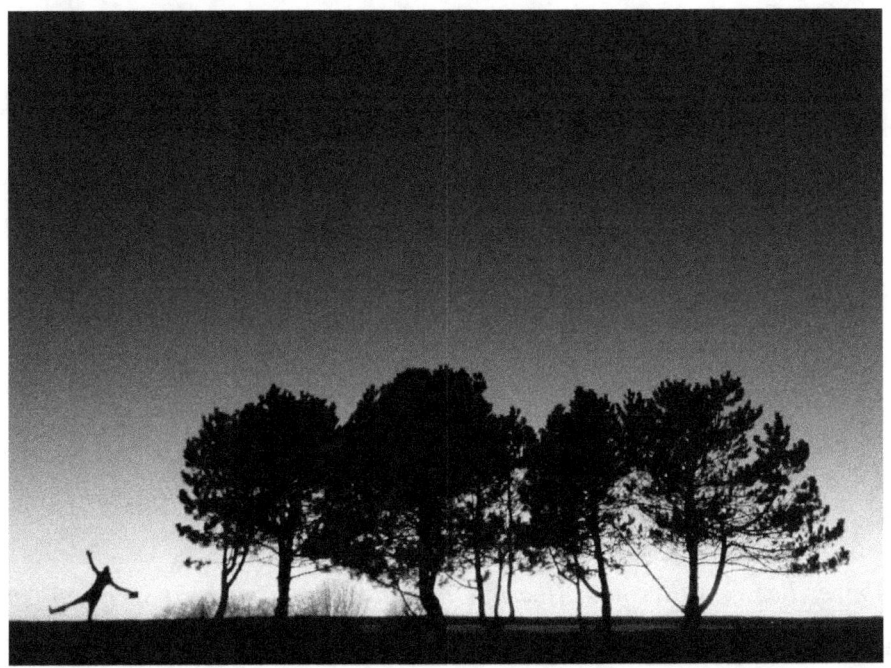

Travelling is great for a ton of reasons (you can read some of them over here). And one of the big ones for us is that it helps us build relationships – not just with folks we meet along the way, but also with family, friends and friends-to-be scattered across the world. And part of the reason we can build those relationships is because we stay connected – even just a little bit – while we're away.

See, by sharing photos of your travels while you're travelling, you keep your loved ones up to date. You give your friends the chance to enjoy your adventures and give you travel tips of their own. And if you drop the local hashtags on your shots, you give locals and other travellers in the area the opportunity to engage with you. Scroll through the photos associated with those hashtags, and you'll find out what cool things other people in the area are doing – *instant travel guide!*

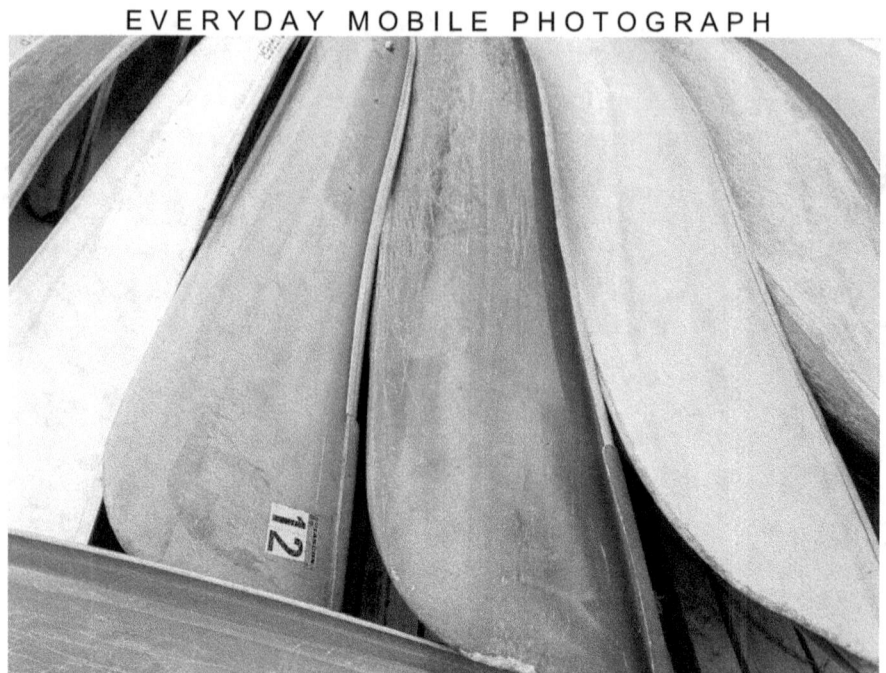

Above: Before we visited Alberta's Icefields Parkway, we'd seen tons of photos of it on Instagram. When we came across a particularly stunning shot, we made a note of its location and plans to check the place out. The photo of the canoes above was taken at one of those spots!

Before we had smartphones, we all tried to keep up with blogging while we were away from home, but we struggled with it. The process of uploading, editing, exporting and posting our images ate into time we felt we should be using to experience and photograph our surroundings.

Now, with smartphones and sharing services, we can take a photo and have it online, edited, with a caption, in a minute or two. Plus, we get all those bonus benefits of plugging into an online community that just doesn't exist with a standalone blog.

So for us, when it comes to photographing our travels, we take a two-pronged approach: We shoot with our DSLR as much as we can, saving

the bulk of the editing and sharing for when we get home. But when we come across a scene we want to share immediately, we shoot it with our phone too. (Lauren and Rob have a DSLR and point-and-shoot equipped with near field communication, so they can easily share shots from those cameras via Instagram as well.)

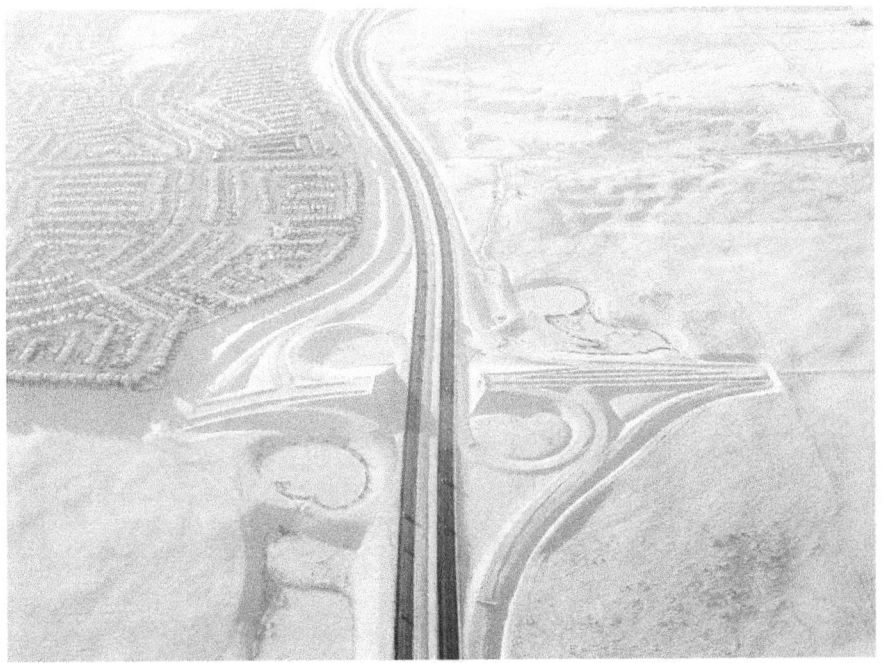

Above: While flying at an altitude where large electronics had to be tucked away, I was able to grab this shot with my smartphone.

And for times when we can't pull our more expensive gear out – like when it's at risk of getting damaged or the situation prohibits proper cameras – we use our phones exclusively and are glad for it! A quick example: Say you're interested in snapping some underwater shots on your next trip but can't bear to shell out for an underwater housing unit for your DSLR – a much more affordable waterproof case for your smartphone can make it possible!

EVERYDAY MOBILE PHOTOGRAPH

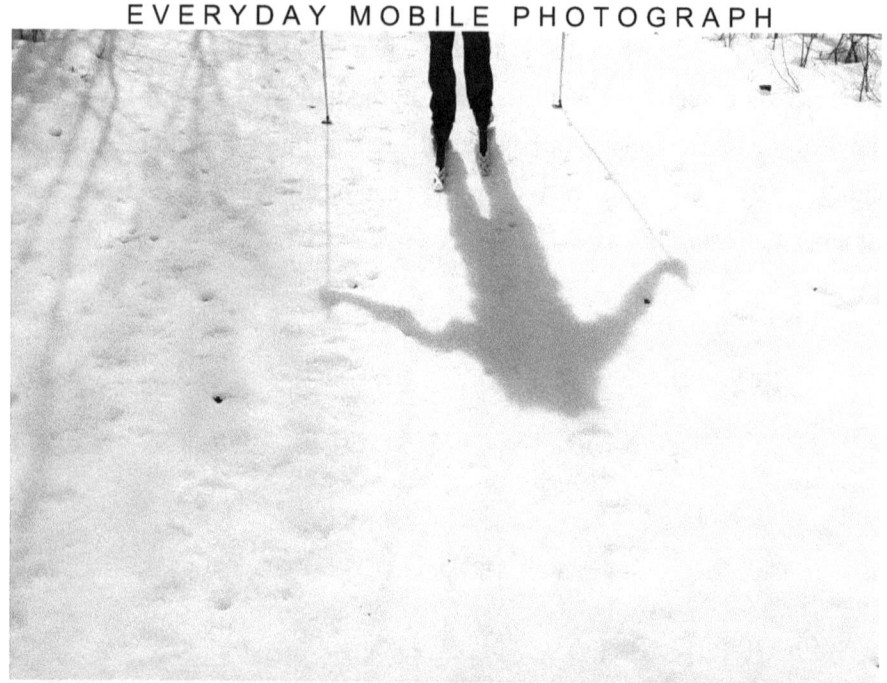

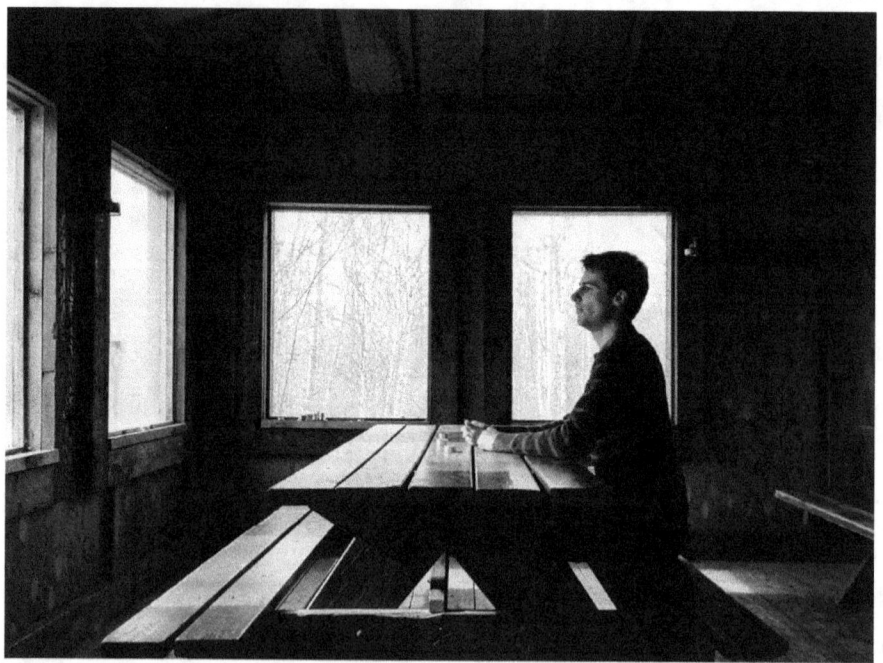

Above: I recently went cross-country skiing for the first time in ages. My

skiing partner predicted (correctly) that we'd do a lot of falling, and so I left my DSLR at home and stuck to my phone's camera.

We've recorded some great sights that would have otherwise gone unrecorded, if not for our trusty smartphones!

EVENTS

Nowadays, when you attend an event there's a good chance that it will have its own hashtag. Here's the idea: If you share anything on social media about the event – a Twitter tweet, a Facebook post, an Instagram photo – you can tag it with the custom hashtag, so that other social media-using attendees can get your take on the event. It's a fun way to connect with other people who are into similar things as you, and to get more eyes on your work!

While you can share and hashtag images of the event that you took

EVERYDAY MOBILE PHOTOGRAPH

with your DSLR, the general trend with event-specific hashtags is to post phone shots. And in cases where you don't want to be lugging a heavy (and more valuable) camera around – say at a rowdy music festival – your phone camera may be perfect for the job.

Both shots in this section were taken at the 2014 Edmonton Folk Music Festival using my smartphone camera. By shooting only with my phone over the course of the weekend festival, I sacrificed image quality (especially on the night shot), but saved myself from lugging around and worrying about my DSLR.

Watch for event-specific hashtags popping up at weddings, music festivals, fundraisers, workshops and even plain old parties. And if you're hosting an event of your own and expect your attendees to be social media types, hook them up with a unique hashtag they can use when they share photos of the festivities!

MICHAELA WILLLOVE
PEOPLE & PETS

If you're a professional photographer or an avid hobbyist, chances are that you've taken some shots of your family and friends with your best camera. Chances are, too, that they may be some of your favourite images because they capture the people in your life that are most important to you.

But unless you're one of those admirable, dedicated folks who always has that camera on them all the time, at the ready, you're likely not taking as many photos of people as you like. Especially of those candid moments, where there wasn't a specific reason to tote your bulkier gear along – like a quick trip to the park or an impromptu soccer game.

So make an effort with your smartphone instead. It is your phone after all, so you probably have it with you on all of those occasions anyway! The photos may not be technically as strong as they would be if you used your DSLR but – and here's the important part – they will be *there*. Pull

EVERYDAY MOBILE PHOTOGRAPH

out your phone, snap the shot, and the memory is preserved.

We humans are inquisitive creatures. We love getting a look into someone else's life – and that means not only seeing what you do and what you like, but also seeing who you are and who you share all of that with. So, if you're up for it, share the smartphone photos you capture of your friends, family and pets – and of yourself too!

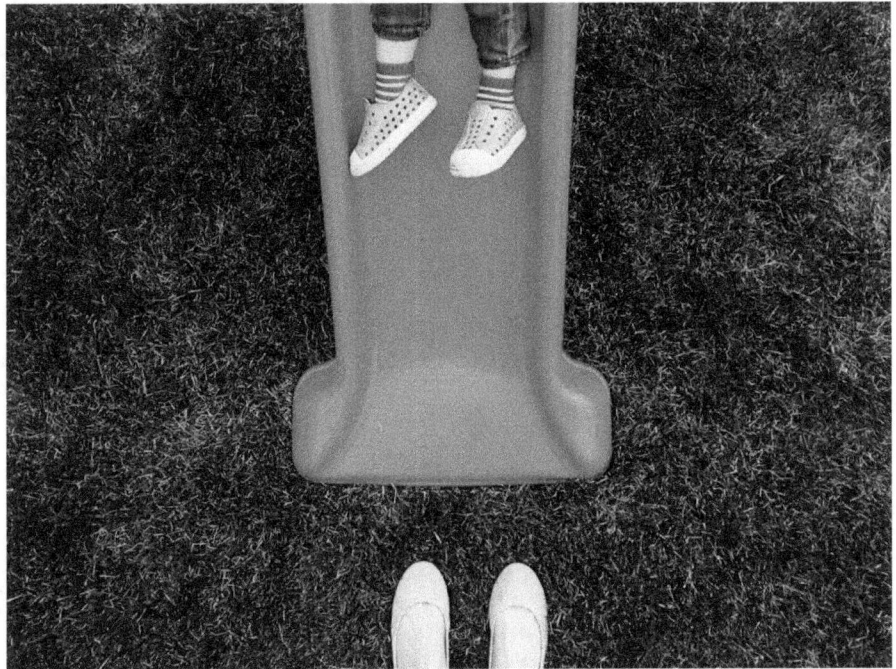

We personally gravitate towards candid shots and save the more creative stuff for our DSLRs, but there are tons of great photographers creating impressive portraits of people and animals with their smartphones.

Whole communities dedicated to sharing smartphone portraits have sprung up on social-sharing sites. You can easily find them by looking at photos submitted under the hashtag #portraits, and seeing what other portrait-related hashtags people have added to their shots. You'll be sure to walk away with tons of ideas on how you can use your smartphone to capture great images of people and animals.

STREET PHOTOGRAPHY

Sometimes, as a photographer, your goal is to go unseen by the world around you and capture a moment that's unspoiled by your presence. That's

EVERYDAY MOBILE PHOTOGRAPH

really the heart of street photography!

> *Street photography is photography that features the human condition within public places and does not necessitate the presence of a street or even the urban environment." – Wikipedia*

But with a camera around your neck, it can be hard to blend in, especially nowadays when there are more photographers out there. The average person on the street may be more attuned to the photographer's presence and more likely to change their behaviour as a result (for example, by politely stepping out of your shot).

Above: With this shot, I could have got away with using my DSLR, but using my smartphone made me a little less conspicuous.

While we wait for Google to invent an invisibility cloak, we have to find other ways to blend in.

Enter: The smartphone. Because most of us have them – and a lot of us have them out, all the time – people may not take much notice when you use it as a camera . It doesn't guarantee invisibility, of course, but it can help to take some of the pressure off the folks around you, making you more able to capture that unspoiled scene. And because it's light and easy to wield, it may also allow you to take shots in situations where a larger camera just wouldn't work.

EVERYDAY MOBILE PHOTOGRAPH

Above: When I took this photo, I was packed into a busy (and moving!) subway car and had to keep one hand on the subway handrail. With a larger camera, I might not have been able to compose the image. I might have also drawn too much attention to myself and inadvertently spoiled the moment!

There are a few things to think about here.
First up, respect: Just because you *can* take a shot with your phone doesn't mean you *should*. It's your job to think about how your photo can affect the person you're photographing, especially if you intend to share it. If you're planning to get into street photography, it's not a bad idea to know the laws with respect to photography and image sharing in the place where you live. We say that not to deter you from taking photos – street photography can be incredibly important, not to mention that it's lots of fun – but just as a friendly heads up!

Second, quality: Though some smartphone cameras offer impressive quality, they're still not on par with DSLRs, and even some pocket-sized point-and-shoots. If you intend to print your work, you may want to weigh the invisibility benefits against the quality costs. You may find you're better off working with a proper camera in some cases.

LINK-THROUGHS

If you host a blog or another kind of website, smartphone photography and social sharing sites can help you engage an existing audience, and build a new audience, for your work!

See, when you post an image to a social sharing site, so long as you have an open profile, pretty much anyone on that site can find it. And with the help of some thoughtful hashtagging, you can increase the chance that it gets in front of folks who will like what you're doing.

EVERYDAY MOBILE PHOTOGRAPH

Above: A smartphone photo of homemade popsicles, shared on Instagram to direct people to the food blog where the recipes were published.

So whenever you publish a great new blog post, or add new images to your portfolio, consider sharing a relevant image on a social sharing site like Instagram to give folks a heads up. Make sure you provide them with a link to your work, too!

The general rule of thumb here is to make sure your image meshes with the style of the social sharing site. For Instagram, that generally means sharing a photo snapped with your smartphone. If you can, then, make a habit of grabbing a few shots of your work on your phone, for sharing purposes.

There's a fine line between giving eager readers a heads up and spamming people, so keep a close eye on how people respond to your images.

MICHAELA WILLLOVE
ART PROJECTS

While we've talked so far about sharing photos in their own right, these days more and more people are using photography – and image-sharing sites – to share their non-photographic artwork. This is especially true of sites like Instagram and Tumblr (the latter of which isn't specifically geared towards photos). In our own Instagramming experience, we've come across drawings, paintings, paper art, collages built from flowers, famous paintings rendered in Playdough (yep, really!) – all snapped and shared with the artist's smartphone!

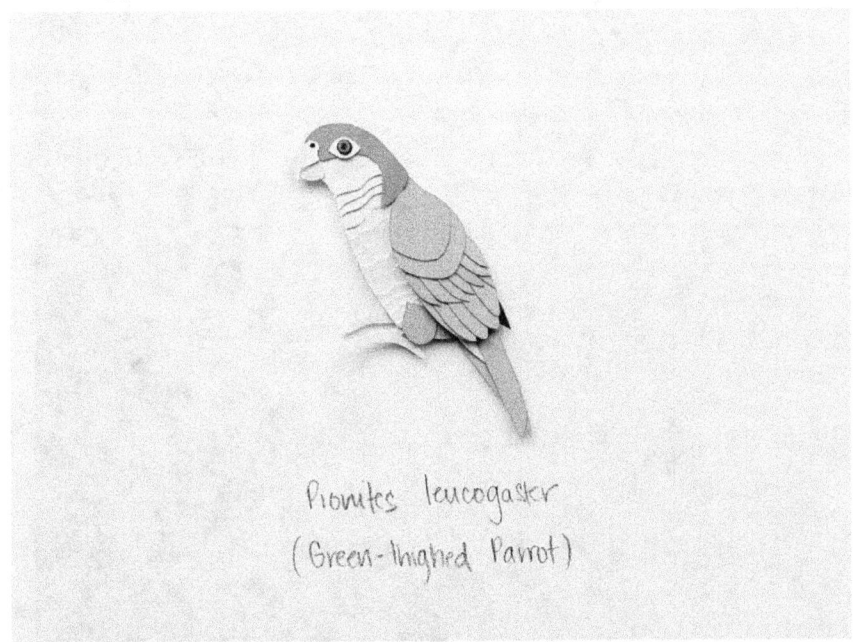

Above: A smartphone shot of a paper parrot – part of a series of paper animals I've been sharing on my Instagram account.

If you have non-photo art you want to share, consider posting shots of it alongside your photography, or create a totally new account dedicated to your craft!

EVERYDAY MOBILE PHOTOGRAPH

Above: A shot of a finished watercolour painting, and a behind-the-scenes

MICHAELA WILLLOVE
look at a similar project, both taken with my smartphone camera.

While it's great to show your audience the finished product, people really enjoy getting a glimpse of the behind-the-scenes action too! Consider zooming out every now and then, to compose a photo that captures your process (or your mess!). It's a great way to engage your audience with your art and allows you to keep with the spirit of sharing service that's more geared towards photography.

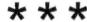

Editing on A Smartphone

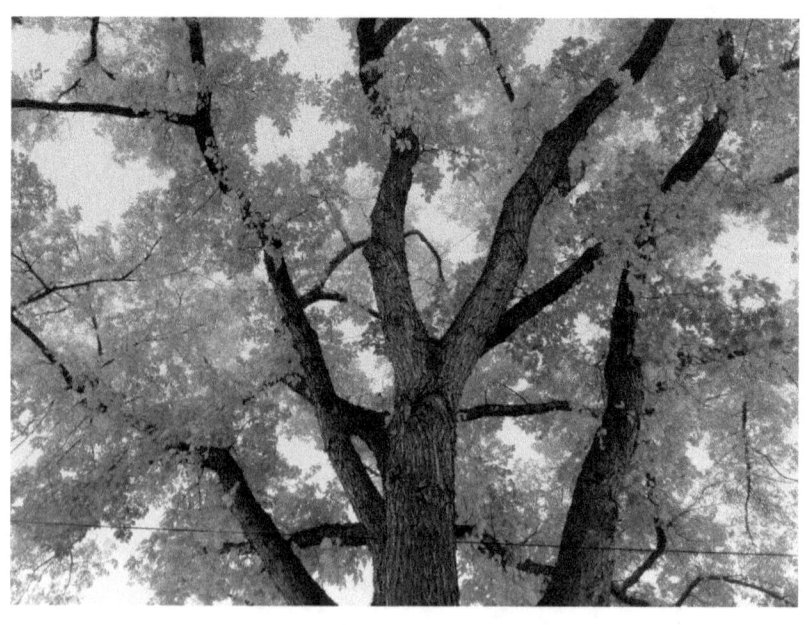

MICHAELA WILLLOVE

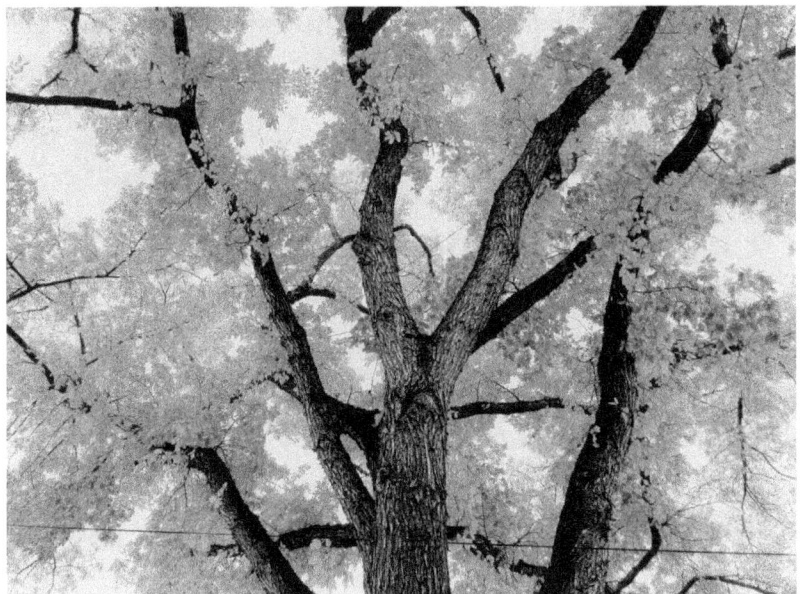

Above: A shot of the golden fall leaves, before and after editing with the VSCO Cam app.

DIGITAL PHOTOS NEED TO BE EDITED to look their best – and that's true whether you're shooting on a DSLR or a smartphone! In this section, we give you a few tips on how to bring out the best in your smartphone shots, whether you're editing them on your phone or your computer.

Editing on Your Phone

Cras a dui at quam fringilla conse- quat. Vestibulum ante ipsum primis in faucibus orci luctus et ultrices posuere cubilia Curae; Duis at ornare libero. Nunc rutrum volutpat tortor, a faucibus augue congue non. Integer ultricies et magna nec iaculis. Sed tincidunt quis felis vel euismod. Nam pretium elit elementum est ullamcorper dic- tum. Praesent dapibus dolor ut lorem hendrerit volutpat. Curabitur vulputate placerat turpis at

luctus. Suspendisse vel aliquam nulla. Nam tristique sed ipsum eget cursus. Aliquam in adipiscing magna. In quis elit nisi. Donec eu lorem ut nisl adipiscing suscipit eget eu libero.

THE BASICS

If one of your goals with your smartphone photography is to share your work quickly, chances are you'll be looking to do your image editing straight on your phone using a photo-editing app.

While these apps aren't as powerful as the professional-level editing programs you might have on your computer, they do allow you to make coarse adjustments to your images, *quickly,* often for no cost or just a few dollars.

There are a lot of editing apps offering a huge range of functions, and the mix is always changing, so take a look at the photo editing apps in your phone's app store to see what's popular. It may take a few tries to track down an app you find intuitive to use and that contains the features you're after.

EDITING FEATURES TO LOOK FOR

Nowadays, apps offer tons of ways to manipulate your original smartphone image. Here's a quick rundown of some of the options available to you. To the best of our knowledge, no one app allows you to do ALL of these things. But in reading the list, you should get a sense of what functions you want, which'll be a big help when you start exploring your app store and looking at what each editing app offers.

And hey, if you're overwhelmed or aren't into editing on your phone, no worries! Share your shot as-is and let the world know that you've gone for #nofilter. Or don't. Totally your call!

EDITING FEATURES TO LOOK FOR

- **Brightness**
- **Contrast**
- **White balance**
- **Color temperature or tint**
- **Saturation**
- **Shadows**
- **Highlights**
- **Sharpness**
- **Crop:** to zoom in on part of your image or change its aspect ratio
- **Straightness**
- **Image orientation**
- **Vignettes**
- **Blur:** to mimic a shallow depth of field or tilt-shift lens
- **Borders:** to work around Instagram's 1x1 crop and maintain a different aspect ratio
- **Border shape:** to remove hard edges from around your frame
- **Text**
- **Virtual stickers**
- **Collages**
- **Filters**

POPULAR EDITING APPS

If you need a little more guidance on what app to use, here's a quick rundown of the major players in the editing app market (but make sure to take a look at your app store to see what's available – you may find something that suits you better!).

VSCO Cam

This editing app for iOS- and Android-enabled phones is one of the most popular out there, thanks in part to its range of filters (both free and paid).

In addition to applying filters, with the VSCO Cam app you can

adjust the basics – brightness, contrast, sharpness, warmth, tint (one of the few we've found that does this!), crop and orientation. You can also change the tone of highlights and shadows, add grain or fade, and make a few other stylistic adjustments.

It's very much geared towards creating a particular aesthetic (that washed out look that's popular at the moment) and so only lets you, say, take the highlights *down* (no up option) and take the shadows *up* (no down option).

Above: *A single photo with various VSCO filters applied. Clockwise from top left, the filters are: No filter (original image), HB2, M5, B5, T1, and A4.*

The filters come from the following series (some series may no longer be available):
HB2 = Hypebeast X VSCO
M5 = Subtle Fade
B5 = Black & White Moody
T1 = Faded & Moody

A4 = Aesthetic Series

PicTapGo

This popular app lets you combine multiple filters to create custom looks, and remembers what filters you like for faster editing! For iPhone only.

Instagram

Most folks may think of Instagram simply as a sharing app, but it also allows you to edit your shots. You can make both upwards and downwards adjustments to brightness, contrast, sharpness, shadows, highlights and warmth (no color temperature) and more. You can also add filters and blur part of your shot using their radial and linear blur using their tilt-shift function.

No Crop

If you're posting shots to Instagram, you'll learn very quickly that the app crops your images to a square aspect ratio. But say you don't want to crop your shot. You'll need an app that will build borders onto your rectangular shot, so that the *image plus the borders* creates a square.

No Crop lets you not only maintain the shape of your shot, but also allows you to perform basic edits, apply filters, create collages, apply text – a lot of the extras you won't find in a straight editing app. This one's Android only, but there are plenty of similar apps out there for other operating systems!

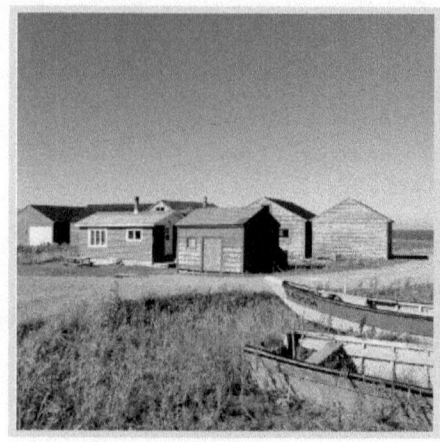

Above: The same image with two different crops. Yellow borders have been added to show the edges of the image. On the left, the image has been cropped to the 1x1 aspect ratio that Instagram automatically applies. On the right, the No Crop app has been used to apply white borders above and below the original 4x3 image, so that the final image+borders fits Instagram's 1x1 requirement.

Editing on Your Computer

Cras lectus ante, egestas quis blandit non, mattis quis metus. Vivamus sapien dui, ornare nec massa eget, porttitor gravida tellus. Donec hendrerit posuere placerat. Nulla facilisi. Cras non orci at nisi rutrum sagittis ac congue dolor. Aliquam pellentesque libero sed libero malesuada laoreet. In venenatis dignissim sagittis. Mauris ligula elit, accumsan vel arcu et, dignissim rutrum dolor. Praesent vehicula lacus nunc, sed feugiat ligula semper et. Nunc id massa venenatis magna ornare faucibus quis sit amet arcu. Nam hendrerit mauris vitae urna pharetra lacinia. Aenean blandit nisi quis urna porta, id euismod magna condi- mentum.

If you want to use a more powerful editing program than what you'll

find in a phone app, not to worry! Simply upload the photos to your computer and edit them with your editing program of choice.

If you're new to editing your images on a computer and are looking to get into it seriously, we recommend checking out Adobe Lightroom – a powerful and intuitive professional editing program. If you're not sure you want to commit, you can download a free 30-day trial here.

Above: Lightroom can help you make more complex and subtle edits than a camera editing app. We used Lightroom to straighten the horizontal and vertical lines, and made the colours pop by increasing contrast, whites and saturation.

If you want to get more creative with your shots – for example by combining multiple images into one, removing or adding major features, or adding text – check out Adobe Photoshop CC (or the pared down version, Adobe Photoshop Elements). You can download a free 30-day trial of either program here.

* * *

MICHAELA WILLLOVE

Sharing Your Images

ONE OF THE BIG DRAWS OF smartphone photography is that it allows you to create and share your work – with folks from all of the world, if you want – in just a matter of seconds!

You see, when you have a phone that connects to the internet, you can upload your shots to all kinds of places – photographic communities, social networking sites, messaging services, emails, and on and on.

It's easier than pie, takes just a little effort to get started, and the potential benefits can be huge! In this section, we'll go over the basics of sharing your work online, talk about some of the pros and cons, and tell

you a bit about the vibrant smartphone photography communities out there today.

#1 Connect to the Web

In order to share a photo on one of the major sharing platforms via your phone, you'll need an internet connection. Either Wi-Fi or your phone's data plan (if you have one) will do the trick! If you're not online, you can't share.

#2 Know Your Phone Plan

Anytime you do something on your phone that requires internet access – like share or download a photo, check your email, or run a backup to a cloud server – you use something called data.

Typically, smartphone users will purchase a certain amount of data from their phone provider, which specifies how much data they can use per billing cycle before they're charged an overage fee. You'll want to keep an eye on how much data you use, to make sure all your image sharing isn't costing you a fortune! Make sure you find out too whether sending photos by text message costs extra.

- **TIPS TO KEEP YOUR FEES DOWN***
- **Share via Wi-Fi:** In general, home/business internet plans allow for more data than phone plans, meaning you're less likely to go over your data allotment if you share via Wi-Fi. That being said, you should know how much data you're using on a home plan, and whether your connection is secure.
- **Run auto-backups of your photos over Wi-Fi:** Running a backup can use a lot of data, so unless you have a super-generous data plan you may want to save the backup for when you're connected to the internet via Wi-Fi. That being said, the longer you go without backing up your work, the more at risk you are of losing your photos. Do what you're comfortable with!

*You know your situation best, so use these tips at your own discretion. You are responsible for any charges you incur!

#3 Places to Share Your Work

Once your phone is internet-connected, you'll need to choose which photo-sharing services you want to use. There's a lot of choice – we'll give you a quick rundown of some of the more popular options.

INSTAGRAM

The Basics

Instagram is by far the most popular sharing service geared mainly towards smartphone photography. As of December 2014, over 300 million users were signed up for the service, including everyday folks, artists, athletes, famous photographers from tons of disciplines (fashion, nature, documentary), talent scouts, brands and more.

The Pros

One of the things we like most about Instagram is its focus on community: There's a real push towards genuine interaction, even when you're connecting with folks with much larger followings than yours (though don't expect to get a response from people whose posts gets tons of comments – there are only so many hours in a day!). And though there will be exceptions, most folks emphasize positivity and encouragement.

Instagram also offers potential for growth: There are tons of stories of people developing huge followings on Instagram and having amazing opportunities come their way (and probably even more stories of people finding new clients, developing friendships, and so on). With so many folks using the service now, it's harder to get your work noticed (though hashtagging can help – more on that in section 5).

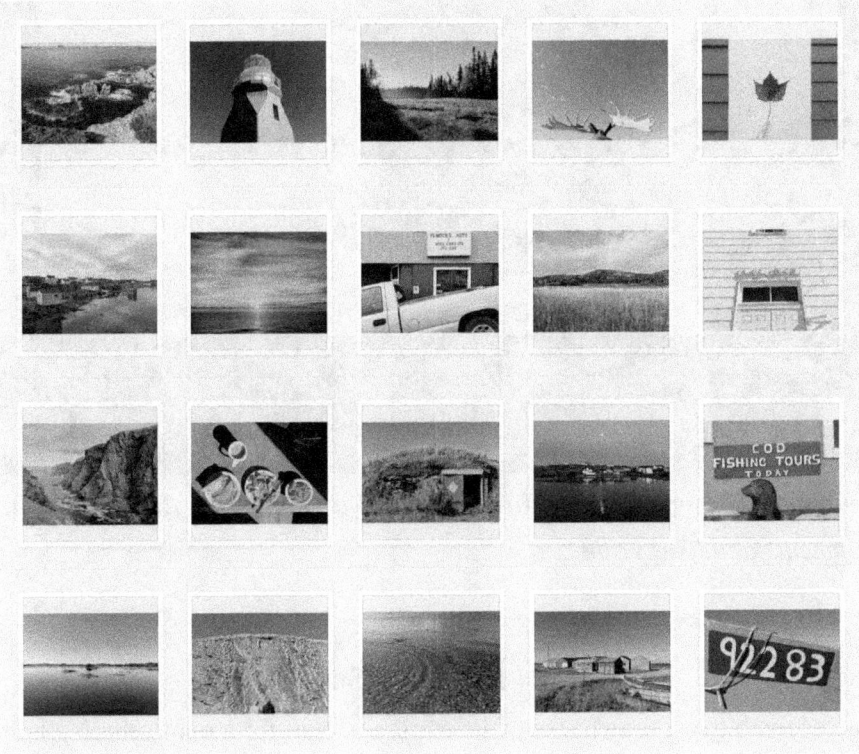

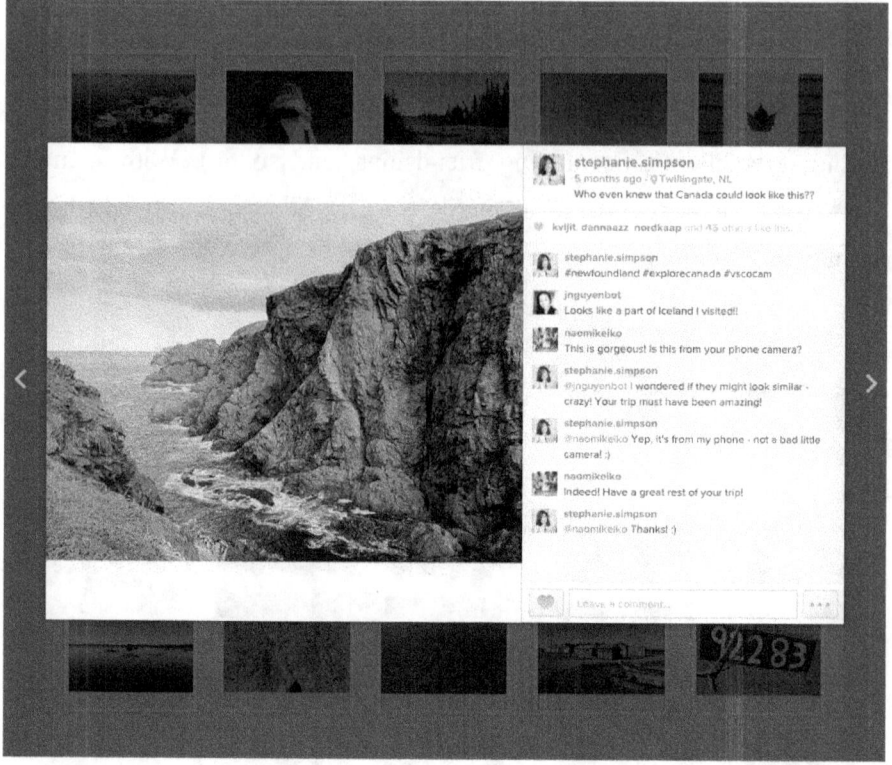

Above: Photos on my Instagram feed, and a single photo enlarged with comments and likes visible.

The Cons

One of the biggest drawbacks of Instagram is that, for a photo sharing app, it doesn't always make your photos look very good. If, like roughly half of Instagram users, you're using an Android device, your photos will be seriously compressed and the quality seriously degraded (iOS users don't seem to have the same problem). The jury is out on whether the issue is mainly caused by Instagram or Android, but either way, the result is the same.

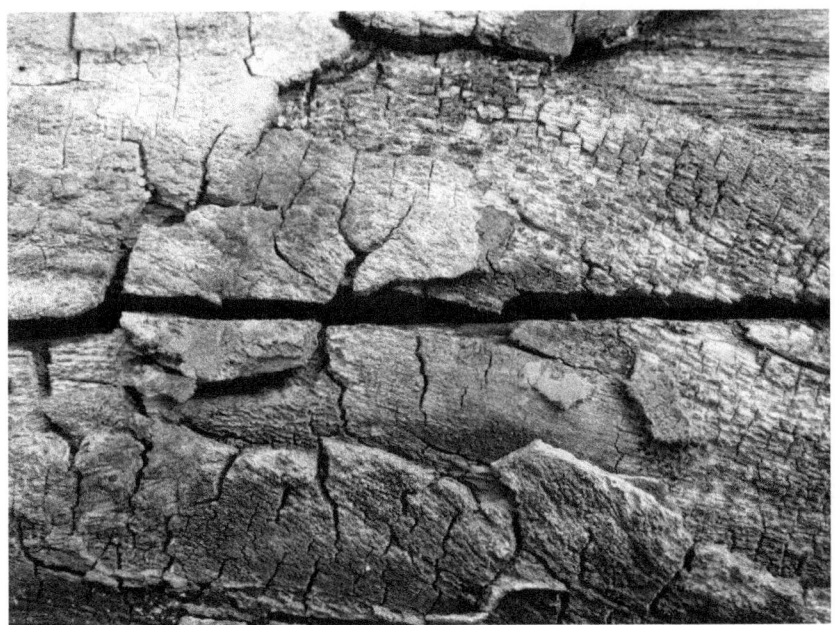

Above: A shot of a log, straight out of my smartphone camera.

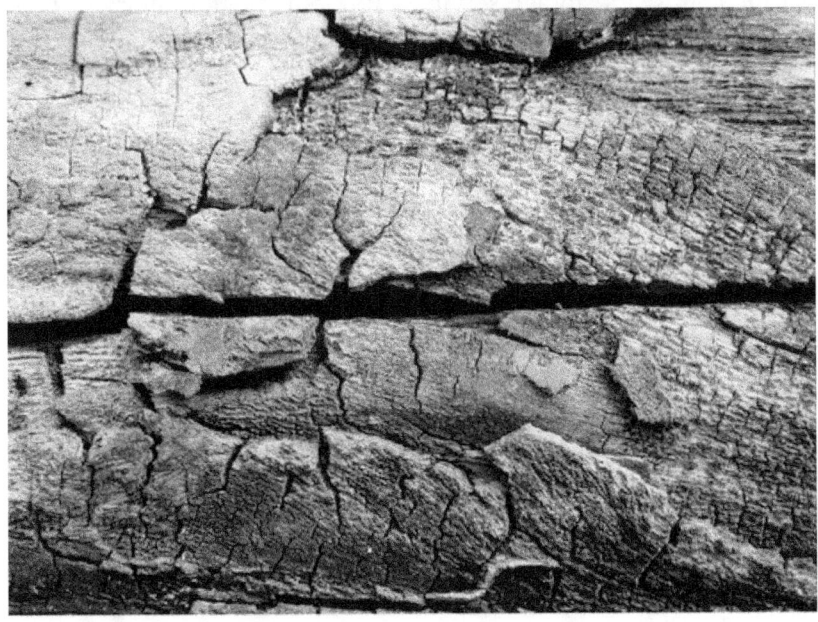

Above: The same shot, with minimal editing, after posting to Instagram. Notice how much less sharp it is compared to the original image.

Some folks aren't happy with Instagram's Terms of Use, which gives

the company license to use your work (your use of the service serves as your permission).

How it Works

Getting started with Instagram is easy: Simply download the app and create an account. You can choose to have a public account, which anyone can see and follow, or a private account, which only people you've approved can see.

Once you have an account, you can start sharing your photos – either by feeding them into the app via your camera app or editing app, or by taking a photo directly through the Instagram app itself. Apply any additional edits you want, add a caption or location information to your shot (which'll allow people to see that location on a map), and hit 'share'. Note that the app isn't a storage service – it doesn't hold a library of your unshared shots.

The trend is towards posting smartphone photos, but expect to see a good number of videos, shots taken with other types of cameras, and non-photographic material (like paintings or digital creations) too.

The culture of Instagram is fairly relaxed, though some folks do play by certain rules: Tag photos you haven't that day with the hashtag #latergram or share those photos on a Thursday (deemed "Throwback Thursday" - hashtag #tbt). And it goes without saying: Get permission before you repost someone else's work.

FLICKR

Flickr is a photo-sharing site that's been around since 2004. While historically it's been more geared towards sharing photography in general, and not *smartphone* photography, the platform is becoming more user-friendly for smartphone users, especially with the most recent update of the Flickr smartphone app. And like Instagram, you can use hashtags to get your work in front of other users.

We haven't shared our smartphone images on our Flickr accounts (yet), but we can see the advantages of giving it a try: The terms of use are more generous than Instagram's, the community is serious about photography, and the platform makes it easier to license use of your images. Plus, Flickr allows you to store your images on their site, which Instagram doesn't. A free membership gets you a terabyte of storage space (and you can purchase more if you so please!). That's a huge draw!

Another bonus of Flickr: The site has been around for over a decade now, so there's a reasonable chance that it (and your carefully cultivated gallery) won't just disappear on you overnight.

TUMBLR, TWITTER & FACEBOOK

Sites like Tumblr, Twitter and Facebook aren't specifically geared towards sharing smartphone photography, but they can be an attractive option, especially if you want to streamline your social media use and share photos, news, and thoughts all from one place. A few words on each:

Tumblr

Tumblr is a free micro-blogging platform that allows you to create short-form blog posts with images (photos or otherwise), videos, gifs and written content. If you're wanting to share a lot of writing alongside your photos, you may appreciate the Tumblr format, as it isn't so rigidly focused on promoting images over words. There are over 200 million blogs registered on the site, so the community is expansive (and probably more varied than what you'll find on a photo-specific site). Hashtag your posts effectively, and they can be seen by a huge number of users!

Twitter

Twitter is a free social networking site that allows you to share writing and captions of no more than 140 characters. At the moment, it's geared much more towards written content – like news, jokes, life updates – than images, but the capacity is there (and it seems to us like the company is trying to emphasize that, so better image-sharing features may be on their way!). If you're looking mostly to share written insights and updates, with the occasional image thrown in, Twitter might be a good place to start. As with the other sites we've talked about so far, hashtags can be used effectively to get your tweets seen by some of its 284 million active users.

Facebook

Facebook is the world's largest social networking site, with over 1.3 billion active users. The site is a sort of social media catch-all, allowing you to send public and private messages, post articles and videos, and share photos – either one-offs or whole albums with dozens of images. (You can also make phone and video calls, send instant messages, and do a suite of

other things.)

The things you post publicly to your Facebook page will show up in your friends' news feed – alongside posts from all of their other friends, plus advertisers. As a result, your work can quickly become buried and go unseen by people who would otherwise be interested in it – a major downside. However, chances are that while *some* of your friends and family may be on the other sharing platforms, almost *all* of them probably have a Facebook account. So if you want to have even a *chance* of sharing images with the people closest to you, you may need to be on Facebook (though an emailed link to a Flickr gallery would do the trick too).

If you want to share your images with strangers, but keep your personal page private, consider making a separate page dedicated to your photography. Keep in mind though: Hashtagging isn't widly used or very effective on Facebook, so chances are your page won't be seen by as many people as an Instagram or Flickr page would, despite Facebook's larger user base.

#4 Read the Fine Print

Before you sign up for a sharing service, you're typically asked to agree to that service's *Terms & Conditions of Use* or a similarly-named policy outlining what you and the service provider can and cannot do as it pertains to the service.

Though these policies tend to be long and written in legal jargon, we absolutely recommend looking through them carefully before you start sharing your work through that service. In some cases, these terms outline that in sharing your work through the service, the service provider gains the right to use your work without seeking further permission (you implicitly provide permission when you sign up).

#5 Post

Once you're set up with a sharing service (or two, or three) and you have a photo you want folks to see, it's time to actually share your shot!

This can be as simple as taking your photo, applying any edits you want, and posting it through your sharing service. But chances are that your service will give you a few more options.

WRITING

Most, if not all, sharing services these days give you the option of presenting writing alongside your images. So before you post your shot, think about whether there's anything you want to tell people about the image – like who it's of or why the scene captured your attention.

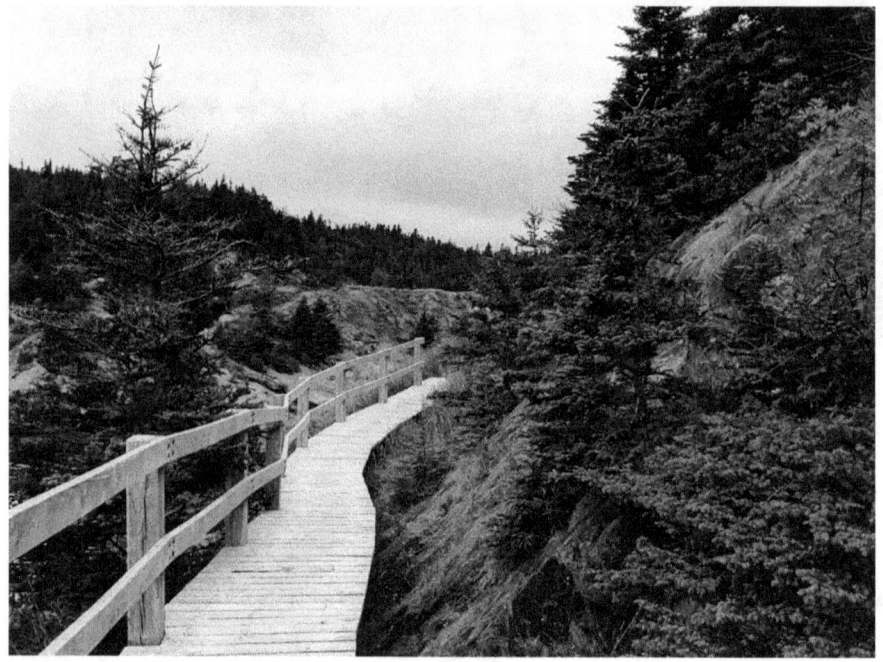

The caption for the shot above was simply, "Shall we?", inviting viewers to imagine themselves in the scene, getting ready to venture down the path.

If your goal in sharing your work is to build a strong audience, think about how you can use words to get them to connect more with your images (and possibly with you as an individual and an artist).

HASHTAGS

Most sharing services these days allow you to add hashtags to your images – words or phrases preceded by the number sign (#example) – typically in the same space where you'd add a caption or description of the image. When anyone searches that particular hashtag, your image will

show up (along with anyone else's image tagged with that hashtag).

> *A hashtag is a word or an unspaced phrase prefixed with the hash character (or number sign), #, to form a label. - Wikipedia*

Hashtagging is a great way to get your eyes in front of a particular audience. For example, lots of brands and organizations these days have not only a social media presence, but a hashtag of their own for fans to use. If you think your image is relevant to them, you may want to apply their hashtag to it to increase the chance that they see it. It doesn't happen often, but they may just get in touch with you to see if they can repost it or license it!

LOCATION INFORMATION

Some sharing services allow you to attach location information to your images, so folks can see on a map where you took your shot (and so that, down the road, you can remember where you went!). It can be a fun feature to use, especially when you're travelling, but some folks aren't comfortable divulging that much information. It's totally your call!

EVERYDAY MOBILE PHOTOGRAPH

Including location information allows people to see on a map where you were when you took your shot!

POST!

Once you've considered all of those extras, it's time to get your image out there! When you post, and how often, is totally up to you, but you'll quickly get a feel for what works best – for yourself and your audience – as you spend some time on the sharing service.

#6 Interact

Many sharing services these days encourage users to interact with each other. Depending on the service, you may be able to: leave a public comment on an image, send a private message to a user, add your name to a list of people who enjoyed an image (by 'liking' or 'hearting'), and sign up to see future images from a particular user.

This means that not only are you able to follow along with other

folks' images and tell them what you think – but they can do the same for you!

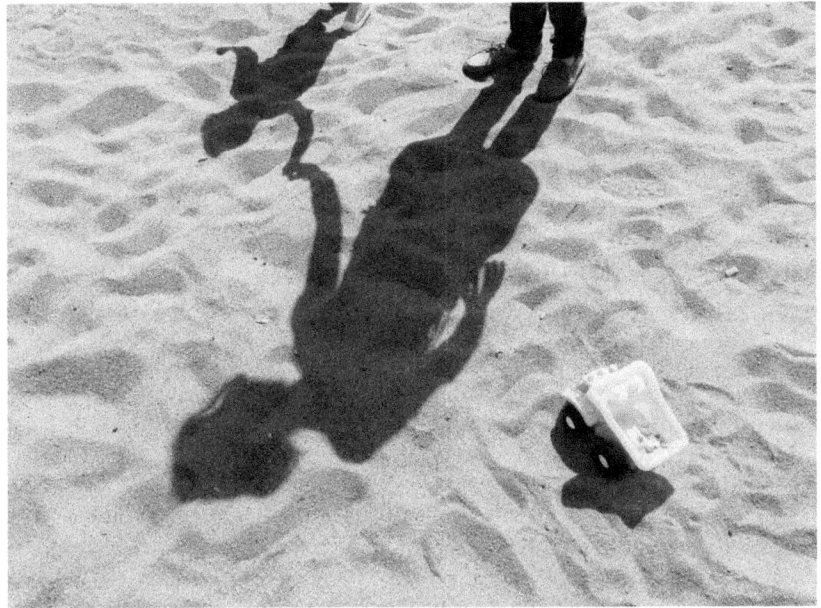

Social sharing services are a great place to make connections!

If you want to receive feedback, the etiquette on these services is that you should be providing it as well, and responding to comments too. Folks aren't as open to engaging with people who don't engage back.

That doesn't mean you have to reciprocate every single time you get feedback – by following someone who follows you, or liking someone's work who likes yours. But don't ignore your friends and fans either!

#7 The Bigger Picture: Pros & Cons of Sharing Your Work

Now that I've walked you through the nuts and bolts of sharing your work,

EVERYDAY MOBILE PHOTOGRAPH

let's take a second to reflect on why you'd *want* (or *not want*) to put your smartphone photos online for the world to see. Here are a few of the pros and cons.

PROS

- Attract new clients
- Make personal and professional connections with other artists (in your area and around the world!)
- Keep your family and friends up to date
- Get feedback on your work
- Direct people to your personal website or portfolio
- Create a sense of responsibility to share more (and practice more as a result)
- Get exposed to and inspired by other artists using the platform
- Create a visual record of your life

CONS

- Open yourself to unwanted attention or criticism
- Open yourself to image theft
- Invest a lot of time in things you may not enjoy, like captioning your images or responding to feedback
- Compromise your vision in order to do what's trendy and gain more likes, comments or followers (it happens!)
- No guarantee that the time you invest will pay off

There are definitely more pros and cons to sharing your work, but those are some of the biggest ones we weighed up when deciding whether or not to share our smartphone photos (and other photos) online. We all decided that sharing was the right decision for *us. Whether you go the same route or not is your call!*

Keeping Your Images Safe

IMAGINE THE PHOTOS THAT'LL BE on your phone six months from now: Birthday parties and family holidays, a great adventure or two, awesome shots of the scenery around your town, the little pleasures of everyday life.

Now imagine you drop your phone and it won't start up again no matter what you try. Or you spill your drink on it and it dies. Or you lose it. Or it gets stolen.

There are a ton of ways you can lose the data on your phone. You need to make sure you don't lose it – and all your photos – for good. You need a backup system.

CLOUD BACKUPS

These days, most smartphones will automatically back your data (including your photos) up to a cloud server...so long as you have that function enabled.

Some phones will allow you to automatically back up your photos to a cloud server!

Make sure to check your phone to see if it has this capability and how it can be customized. For example, some phones allow you to specify what you want to back up, and whether you only want to run backups when you're connected to Wi-Fi (this'll save you from eating up a ton of your phone data).

In addition to helping keep your photos safe, enabling your phone's auto-backup system can make life a whole lot easier should you ever need to wipe your phone entirely, as it may allow you to restore some of your apps and settings with the touch of just a few buttons.

OFFLINE BACKUPS (DON'T NEGLECT THESE!)

When it comes to backups, there's no guarantee that any one system you use is going to work. The photos that are stored on your phone may be wiped out. You may think you're backing up to a cloud server, but it may turn out that you accidentally disabled that function ages ago.

So what do you do? When it comes to backing up photos, you need to store your files in at least three distinct places, to minimize the chance that you totally lose your data.

For phone users, this means that in addition to keeping your photos on your phone and on a cloud server, you need to put them on a computer and, preferably, on a hard drive or two as well.

That means getting in the habit of regularly transferring your images (and any other essential data) to your computer and an external hard drive. As a plus, if you run regular backups of your images to your computer and hard drives, you'll be able to delete old shots from your phone and free up precious space for new images!

Printing Your Images

ONE OF OUR FAVOURITE THINGS about taking shots with our phone is getting those images off of our phone and into our hands. There's nothing like a tangible print that you can hold in your hands!

With smartphone photography growing in popularity, there are now plenty of great options for printing your work. Here are a few that have caught our eye recently.

Ways to Print Your Smartphone Shots

Fujifilm Instax SHARE Smartphone SP-1

This little printer – it's not much bigger than your phone – lets you print images from your phone, wirelessly, on Instax film! It's a bit of a novelty,

but we had tons of fun with it when we tried it out, and can see it being great for portrait photographers and anyone with young kids. Read our full review here to see if it's something you might want to add to your kit.

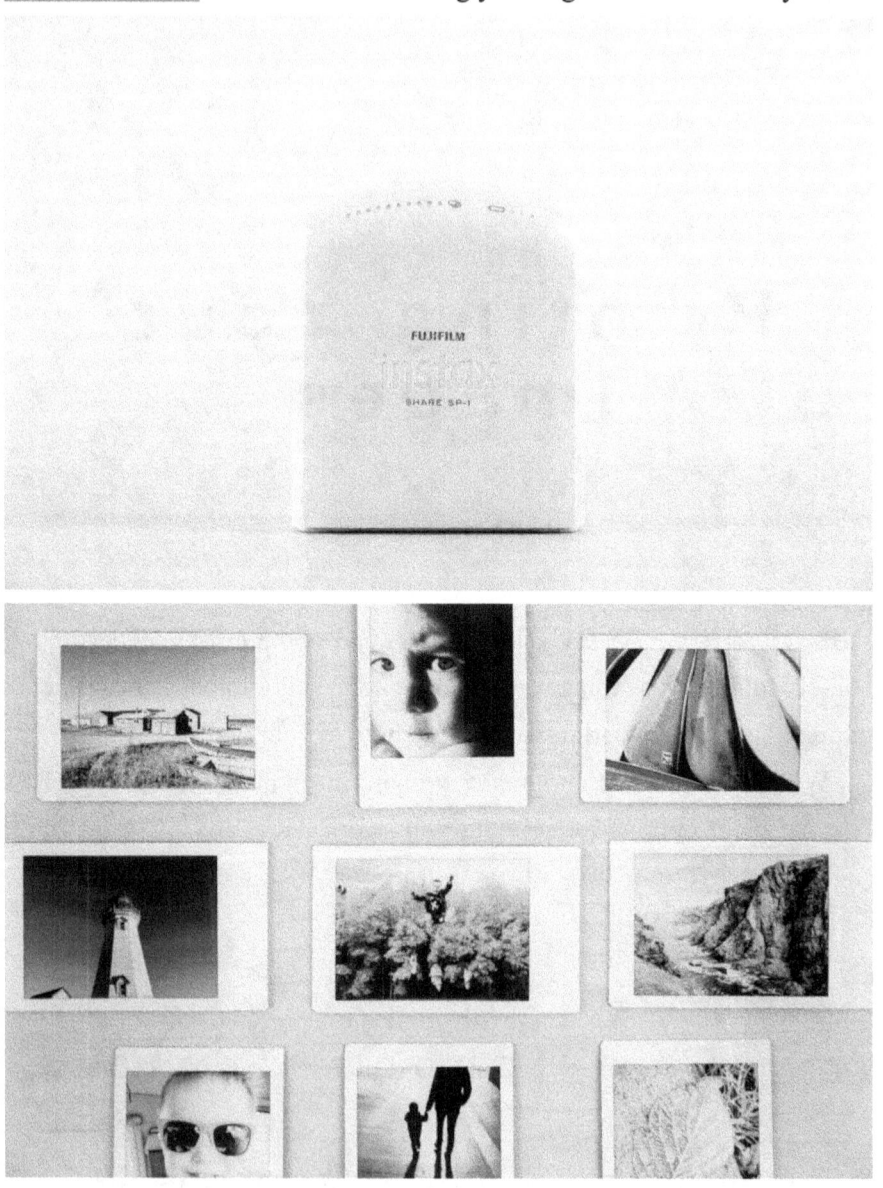

Above: The Fujifilm Instax Share Smartphone Printer SP-1 and a few of the prints we created from smartphone shots and DSLR shots that we transferred to our phone.

Blurb Instagram Photo Book

Blurb is one of the biggest names in self-publishing and album printing. Now, they offer Instagram-specific photo books that allow you to make a book that draws images directly from your Instagram feed. A 60-page, 7x7-inch book starts at US$20.99 (taxes, shipping and other fees not included).

Artifact Uprising Instagram Photo Book

Another popular name in the photo book market is Artifact Uprising – an American printer owned by VSCO (the same ones who make the apps). Like Blurb, they offer an Instagram-specific photo book option that allows you to populate your book with images taken directly from your feed. A 40-page 5.5x5.5-inch book starts at US$17.99 (taxes, shipping and other fees not included).

Other Photo Books & Prints
If you don't post your photos to Instagram, or don't want to populate your book with compressed images (in general, the shots on your Instagram feed are much smaller than the originals on your phone), try creating a photo book or photo prints from the full-sized images on your phone.

We go this route to preserve photo quality, pulling our phone shots into Adobe Lightroom for a quick edit and exporting them as full-sized files before printing. To keep the quality of the print high, we keep the *size* of the print small – with our 8 megapixel smartphone camera, prints of 4x6 or smaller looked the best.

-

EVERYDAY MOBILE PHOTOGRAPH

Above: A 6x8 Artifact Uprising book, made with smartphone photos. I wanted to ensure the image quality in the book was as high as possible, so instead of filling the book with images imported directly from Instagram, I used full-sized files that I had edited in Lightroom.

Conclusion

SMALL THOUGH IT MAY SEEM, taking photos with your smartphone can be a hugely rewarding experience. It can help you improve your fundamental skills, get you inspired, help you build friendships and work relationships, and create for you a visual record of the moments in your life, big and small.

We hope you've found this guide helpful, and that you feel equipped with everything you need to know to take, edit, share, save and print awesome shots right from your phone.

We can't wait to see where your smartphone will take your photography. It's going to be great!

About the Author

Michaela Willlove, M.Sc. is an active engineering practitioner and a computer science book writer. A lot can be assumed when you first see Michaela, but at the very least you'll find out she's good-natured and intelligent. Of course, she's also trusting, respectful and idealistic, but they're far less prominent, especially compared to impulses of being monstrous as well.

Her good nature though, this is what she's pretty much known for. There are many times when friends count on this and her sensitive nature whenever they need help.

Nobody's perfect of course and Michaela has less pleasant traits too. Her disloyalty and negativity aren't exactly fun to deal with on often personal levels.

Fortunately, her intelligence shines brighter on most days. She continued his PhD at the Queen Mary University of London in Human Computer Interaction field. She writes and speaks at various events in Germany & UK.

Acknowledgments

If you enjoyed this book, found it useful or otherwise then I'd really appreciate it if you would post a short review on Amazon. I do read all the reviews personally so that I can continual-ly write what people are wanting.

Again, thanks for reading! Please add a short review on Amazon and let me know what you thought!

www.ingramcontent.com/pod-product-compliance
Lightning Source LLC
Chambersburg PA
CBHW072156170526
45158CB00004BA/1675